Within the covers of this hand-crafted leather volume lies the legacy of Dwight David Eisenhower. The man who gave the world his talents as soldier and statesman, also gave us a rich expression of his inner thoughts through his paintings, done in rare moments of solitude snatched from his constant demands of duty. Through arrangements with his beloved Eisenhower College, to whom he assigned all royalties from the reproductions of his paintings, 50 of the works he modestly called his "daubs" are presented here. This special, limited edition of the Eisenhower College Collection proudly takes its place alongside other valuable art books and preserves the legend of the man called "Ike."

A LIMITED EDITION

Number *142* of 1,500 specially bound copies / presented to

Everett Latta

from

Brown & Bigelow

Library of Congress Catalog Card No.: 72-85342

THE EISENHOWER COLLEGE COLLECTION

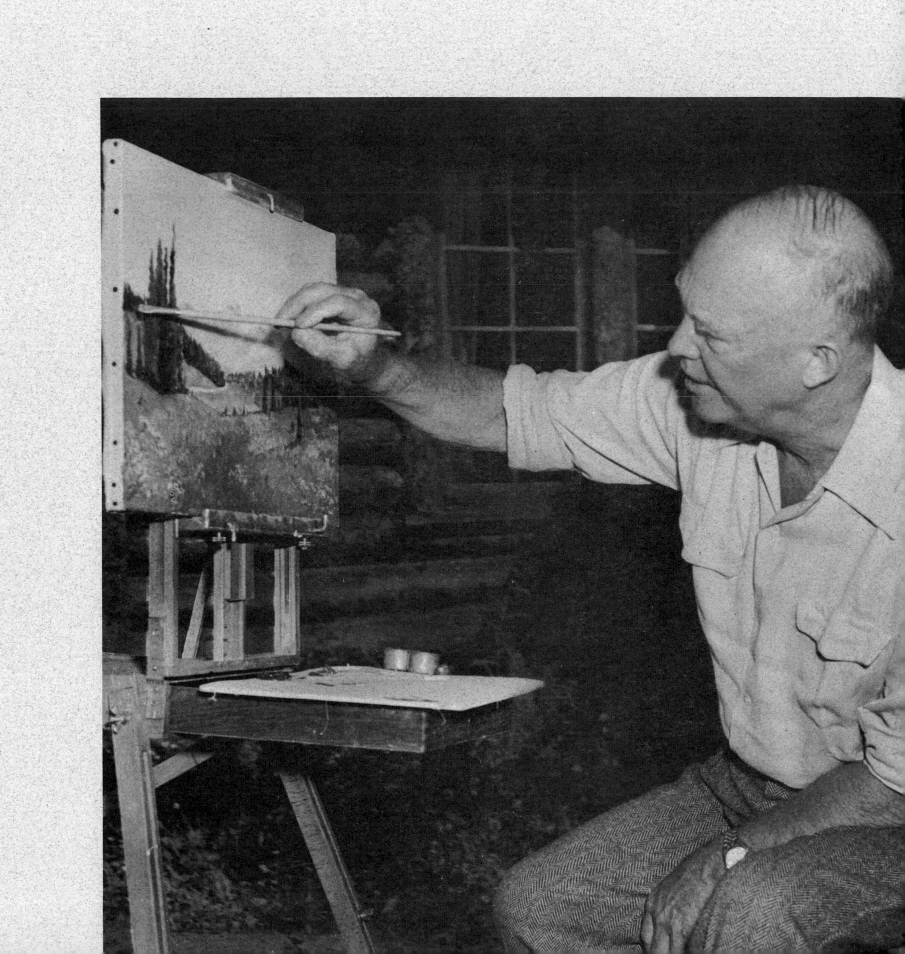

THE
EISENHOWER COLLEGE COLLECTION
THE PAINTINGS OF DWIGHT D. EISENHOWER

Text by Kenneth S. Davis
Critique by Frieda Kay Fall

NASH PUBLISHING, LOS ANGELES

Library of Congress Catalog Card Number: 72-85342
Standard Book Number: 8402-1289-5

Published simultaneously in the United States and
Canada by Nash Publishing Corporation,
9255 Sunset Boulevard, Los Angeles, California 90069.
Printed in the United States of America.

First Printing.

CONTENTS

LIST OF PLATES

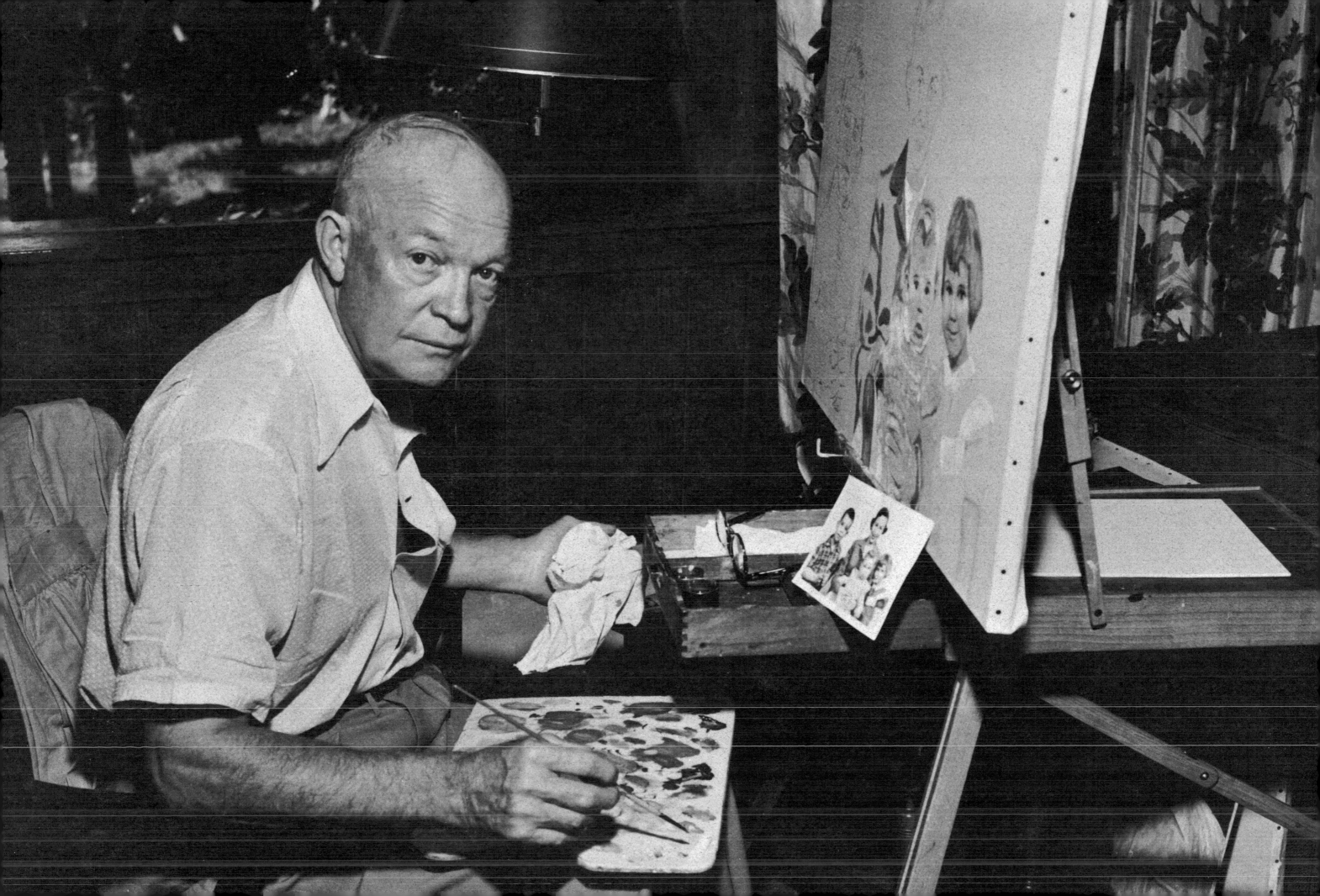

DDE

October 10, 1967

Dear John:

I am glad to give to Eisenhower College, and I do so by
this letter, all rights to reproduce any of my paintings
in 1967 at the Gallery of Modern Art in New York City,
providing the present owners of the paintings furnish
their written consent, and to sublicense or reassign any
of such reproduction rights for the benefit of the College,
without any limitation as to time, again providing the
owners agree.

I hereby give my permission to use my name as artist in
connection with such reproductions, but with the inclusion
of a general statement that some of my paintings are re-
productions of other works.

Sincerely

Dwight D. Eisenhower

Mr. John Rosenkrans
President
Eisenhower College
Seneca Falls, New York 13148

ABOUT THE BOOK

Nash Publishing is extremely proud to present *The Eisen-
hower College Collection: The Paintings of Dwight D. Eisen-
hower,* the most ambitious project in our company's history.

When we first heard of the existence of the paintings, through
Roy Begley and Lloyd Reich of Brown & Bigelow, we were
immediately excited about the possibility of assembling this
work. Here was an art book and a history book rolled into one.
More so, here was a panorama of the American scene—its
towns, its countryside, its people—as only a chosen leader of
this great nation could see it.

We first saw many of the paintings in the form of photo-
graphic color negatives. We remember the day we unwrapped
the first package—holding them up to a clear California sky
to see them for the first time. It was almost a mystical experi-
ence, as if a great man from the pages of history had come to
visit with us.

In a time when modern artists try to distinguish themselves
with unique or bizarre styles, here was a man who—in the
Romantic tradition—strived within the limits of his artistic
abilities to portray the world as he saw it. He painted for
beauty, not for shock value. He looked for the good in life, not
the defects.

Art historians say that an artist's choice of subject reveals
his personal philosophy; the kinds of subjects he chooses to pre-
serve on canvas reveal the values he seeks in life. If that is so,
these paintings tell us more about Eisenhower the man than
any biography ever written. They reveal the gentleness of
spirit, the simplicity of life-style, the sincerity of purpose, the
search for a pure, clean way of life, the deep and genuine con-
cern for people.

Dwight David Eisenhower is already honored and revered
as one of the great presidents of all time, as one of the great
leaders in world history. Here, in his paintings, he is revealed
as a great artist, a lover of his land and its people.

The Brown & Bigelow organization of St. Paul, Minnesota,
which had obtained the original reproduction rights for use in
calendars and other business reminders, gave us their fullest

cooperation in making available photographs and graphic materials which they had assembled.

The Eisenhower College provided not only the permissions but also invaluable reference materials in the form of questionnaires supplied by the original owners of the various paintings.

We were fortunate, also, in being able to obtain the assistance of Kenneth S. Davis, a well-known political biographer and authority on Dwight Eisenhower, who prepared the essay on Eisenhower's background, with particular emphasis on its applications to his paintings; and that of Miss Frieda Kay Fall, a noted art historian and Assistant to the Deputy Director of the Los Angeles County Museum of Art, for providing the art critique and the captions for the color plates.

I want to thank our own staff—Lynne Brown, formerly of *Newsweek's* Book Division, who served as editor; Sylvia Cross, our executive editor; Ron Rubenstein, our art director and designer; and Robert Meisterling, our production manager. We are also indebted to Rick Schmitz of Barnes Press, who coordinated the printing, and Marv Getlen, of New World Book Manufacturing, who served as production consultant.

NASH PUBLISHING
Edward L. Nash, Publisher

* * * * *

General Eisenhower loved to hunt, read Western stories and play golf. He also became a modest but ambitious painter during his years as president of Columbia University. His interest in painting resulted from a continual curiosity to experiment and his growing fascination with color.

Wherever he might be, from Atlanta to his Gettysburg farm, the beauty of woods, rivers and lakes delighted him. When he didn't paint scenery firsthand he painted it from photographs and magazine illustrations. Yet he found painting portraits of his friends to be more challenging—and more frustrating. He attempted more likenesses—and subsequently destroyed more of them—than anything else. When he finished a painting he seldom looked at it afterward. But these products of his leisure hours would be given to personal friends as mementos of special occasions or as thoughtful holiday gifts.

If Eisenhower's humility about his painting talent, his warm candor and lack of pretension were to be respected, the public would never have had the opportunity to see a published collection of his works, for his sense of appropriate conduct would not allow him to sell his work and thus capitalize on the esteem in which he was universally held.

But the public was (and is) interested in Eisenhower and in his artistic expression, the results of his highly rewarding hobby. Therefore, with the best interests of his beloved Eisenhower College in mind, he consented, in 1967, to the reproduction of his works, and they are now known as the Eisenhower College Collection.

At that point it was established that Brown & Bigelow, with its long reputation for high-quality, full-color printing, would be the first to commercially reproduce and distribute Eisenhower's paintings as calendars, portfolios of prints and other graphic products. Since that time there has been a desire to publish the collection in a more enduring form as a fine volume.

We thank Mr. John Rosenkrans, president of Eisenhower College, for his valuable cooperation and considerable help. We also wish to thank Mr. Thomas Stephens for his thoughtful gift to the general, the gift of encouraging artistic expression.

It is with great honor that Brown & Bigelow has become associated with Nash Publishing Corporation for the purpose of making available the paintings of the Eisenhower College Collection in this unique, high-quality volume.

BROWN & BIGELOW
James Day, President

EISENHOWER, THE MAN AS PAINTER

by Kenneth S. Davis

THE FIRST EISENHOWERS

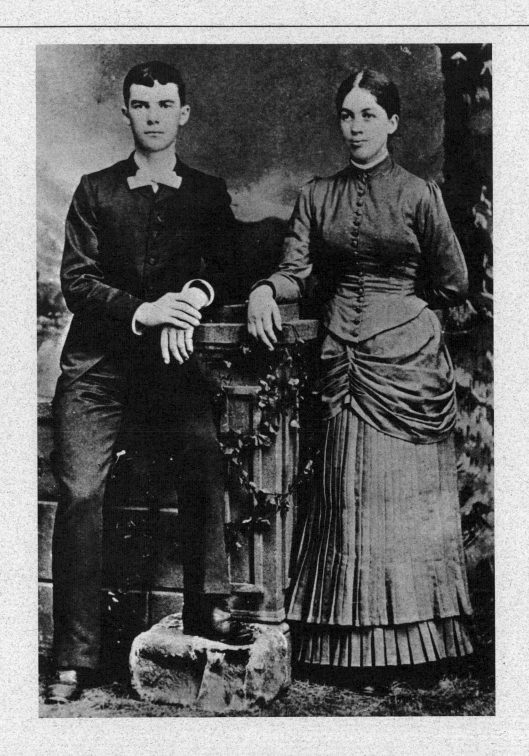

Eisenhower's mother and father pose for a picture commemorating their wedding day, September 23, 1885. David Eisenhower and his new wife, formerly Ida Elizabeth Stover, met in 1884 at Lane University.

On a high ground of probability, one assumes that Winston S. Churchill planted in wartime the seeds whose cheerfully haphazard growth came to harvest a few years later, the colorful fruits now gathered into the collection of Dwight D. Eisenhower's paintings—the reproduction rights of which he gave to Eisenhower College so they have come to be called the Eisenhower College Collection.

Certainly there was nothing in Eisenhower's family background and boyhood environment to encourage in him the notion of painting pictures as a recreative pastime, much less encourage his consideration of art as a possible vocation; quite the contrary, in fact. And of Eisenhower more than most men it can be truly said that what he had become by the time he left his boyhood home was what he remained, in mind and character, for the rest of his life.

Born on October 14, 1890, in Denison, Texas, where his father was temporarily employed in the shops of the Cotton Belt Railroad, David Dwight Eisenhower (thus was he christened; he later reversed the given names) was brought in his mother's arms to the Kansas town of Abilene when barely seven months old. He grew up in Abilene as the third eldest of six sons (a seventh died in infancy) in a family whose economic circumstances were severely modest even by the modest standards of that time and place.

The father, David Eisenhower, was an honest, intelligent, hard-working man of no great personal force, rather dreamy and withdrawn of temperament, who had suffered a terrific blow to his slender ambition and self-confidence when he failed as a storekeeper in the tiny village of Hope, Kansas, a year or so before his third son's birth. From that blow he never fully recovered. His departure for Texas was in the nature of a flight from realities he could not face, and his return to Kansas was the opposite of triumphant. The job offer which brought him back, nominally that of "engineer" but actually mechanic in Abilene's Belle Springs Creamery, came to him only because his brother-in-law, who became his boss, was plant foreman. It paid less than fifty dollars a month and was accompanied by no promise of great future advancement. Nor did advancement come to him. He remained at the creamery for twenty years. By the time he changed jobs (he went to the Abilene office of United Light and Power to take charge of an employees' benefit and savings program), his third son was a somewhat overaged plebe at West Point. And in all those twenty years his highest monthly wage was considerably less than one hundred dollars.

That this family of five which had grown to eight by the turn of the century (the youngest, Milton Stover, was born in 1899) could live in Abilene on so meager a cash income—and live healthily, happily, respectably—was very largely due to the boys' mother, Ida Elizabeth Stover Eisenhower. She was truly a remarkable woman. In many ways in mind and temperament she differed greatly from her husband: whereas he was often dour and inclined toward withdrawn passivity, she was vivaciously active, an outgoing personality possessed of great warmth and charm. In situations where he was inclined to give up the battle, she became a stubborn warrior for what she deemed to be her rights and the rights of her family.

A case in point is provided by the disaster of the Hope general store. David Eisenhower had a partner in that sad venture, a young man named Milton Good, and David became convinced at last, rightly or wrongly, that his partner had been cheating him and that it was the reason he went bankrupt. Soon thereafter, he was quite certain that the lawyer to whom he entrusted his debt-burdened affairs was also cheating him—and it is

doubtless true that the lawyer did nothing effective to prevent his ruin, and that the lawyer's fee was a significant item in the final reckoning. But David did not fight back. Ida did. While he fled to Texas, escaping into the first job that presented itself, she remained in Hope, her second pregnancy then well advanced (Edgar was born in the first month of 1889), and managed to obtain some law books, studying them as best she could, and using what slight knowledge she thus obtained in a determined effort to salvage by legal action all that could be salvaged from the wreckage of her youthful dreams. She failed. Against the clamorous demands of creditors she could save nothing except a few household furnishings and a handsome ebony piano that she had owned at the time of her wedding, having bought it out of the small inheritance that was hers when she came of age. But her failure came from no lack of daring, of trying.

Her courage, determination, and persuasive charm were joined to a marked talent for administrative organization and leadership. It was a talent applied wholly to the management of house and family—these, under the pressure of harsh necessities, absorbed all her attention, strength, and energy—but within this small compass she applied it brilliantly.

When David Eisenhower first returned from Texas, he moved his family into a house on South East Second Street, just south (which was the "wrong" side) of the Union Pacific and Santa Fe railroad tracks that, running side by side, divide Abilene into north and south. On the North Side lived the "best people" —the relatively affluent merchants, bankers, lawyers, doctors, and owner-managers of the town's few small industries. Three or four of these people lived in houses large enough, pretentious enough, to have been deemed mansions even had they been in long-settled eastern communities. On the South Side were the wage-earners—the railroad laborers, the store clerks, the carpenters and bricklayers and mechanics—who lived in unpretentious frame houses generally quite small in size. The Eisenhower cottage was tiny indeed for a family of five, and set upon a small lot much too restricting to contain the play of three intensely active and highly vocal boys. Close neighbors complained to Ida of constant boyish trespass, of incessant excessive noise; and Ida complained to David that she was forced to spend most of her time "trying to keep the boys quiet and out of other people's yards." It was, said she, "a terrible strain on both the boys and me." David, however, could afford no larger dwelling until seven more years had passed and his family had grown to seven. He could afford it then only because one of his brothers, Abraham, a veterinarian, decided to move to California and offered his home to David at a modest rent, with an option to buy later on.

It was this house that became world famous in the 1940s as the boyhood home of the Supreme Allied Commander, and it was by that token destined to become, through the backward echoing effect of time, the boyhood home of a president of the United States. It stood on a corner lot. Its address was 201 South East Fourth Street, which means that it faced south, fronting the southernmost street in Abilene, and had to its west what was then the South Side's easternmost street, Chestnut. Across Chestnut stood Lincoln School with its full block of schoolyard—the grade school which all the Eisenhower boys attended for the first six years of their formal education.

One can imagine Ida's calculating joy as she surveyed this new domain, on a bright spring day in 1898, measuring its resources and planning their fullest use. The house was enough larger than the South East Second Street cottage to seem large indeed to the happy mother. It consisted of two full stories and

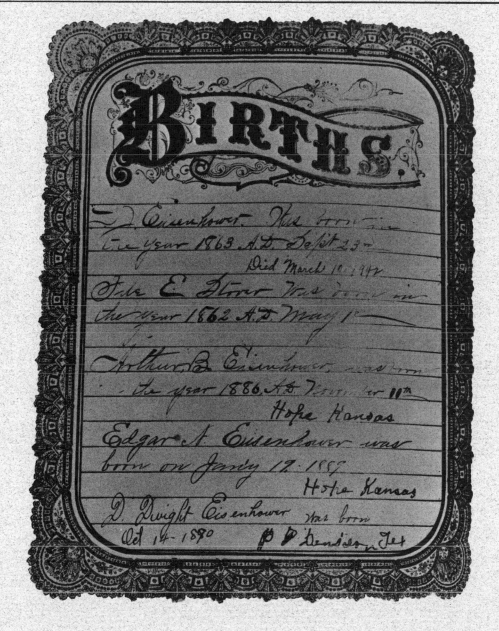

The Eisenhower family Bible was used to record the family genealogy; the birthdate of the future president is at the bottom of the page. The order of his first and middle names was later changed to distinguish him from his father, David Dwight, after whom he was named.

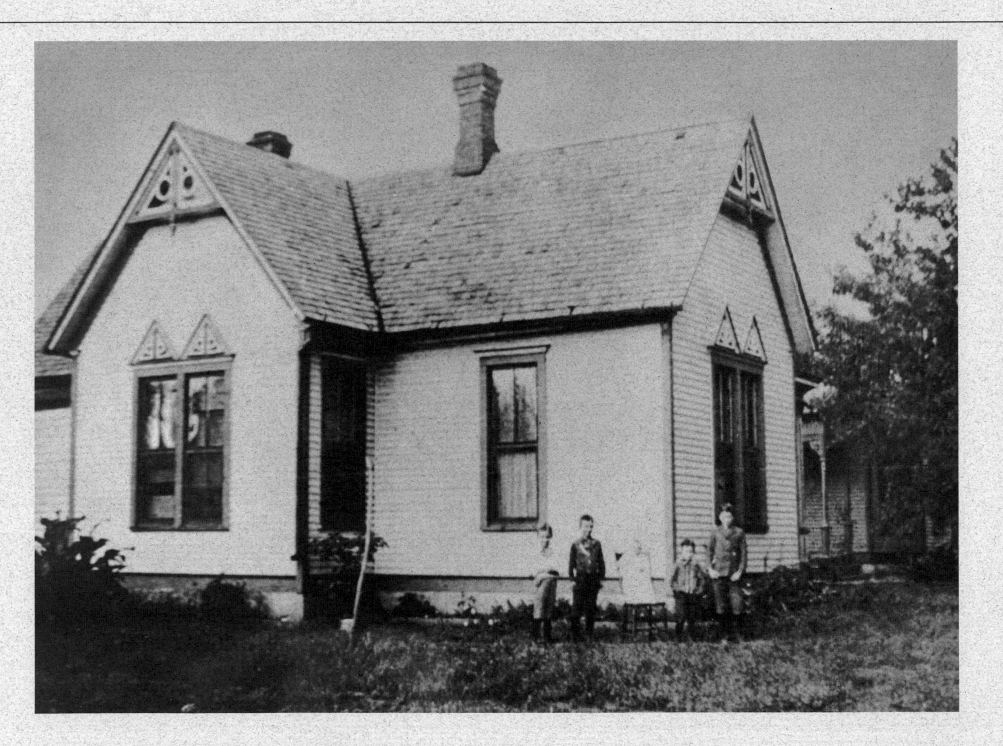

a sizable attic. Moreover, its inner space was divided into many rooms. They were small rooms, but even though the boys doubled up, as they would have to do, in the bedrooms, they were insured the possibility of privacy that had been impossible before. Outside there was space enough for the boisterous play of the boys—space enough between them and their neighbors to bring their noise down to acceptable neighborly levels. The front lawn was narrow. Only a few paces separated the front porch steps from the packed earth sidewalk (not until many years later was it paved with brick). But behind the house was a very large backyard at the bottom of which stood a huge barn with an immense hayloft (it could hold seven or eight tons of loose prairie hay); and to the east of these structures, as a part of the property, lay almost three acres of rich soil. Approximately a half acre of this would be devoted to vegetable gardening, producing all the fresh vegetables the family could eat in the warm seasons and all that Ida could can for winter, with a surplus that the older boys could take in a wagon across the tracks for house-to-house sale on the North Side. There would be a large strawberry patch; a small orchard of apples, cherries, pears; a small vineyard—and these, too, would supply all the family needs, with a surplus for sale. An acre of field corn, or kafir, and an acre of prairie hay would yield more than enough feed for the horse, the five pigs, and two cows, and for the chickens, ducks, guinea hens, and Belgian hares which they would raise at various times—livestock supplying all the family's meat (home-cured in a backyard smokehouse), all the milk, and all the eggs, again, with some surplus for sale. Thus would the father's meager wage be stretched and supplemented by the home labors of his wife and children; all of them, save the youngest, would also earn wages themselves through part-time work in the creamery as soon as they were old enough,

The five Eisenhower boys in 1896 pose for a group picture in front of their first home in Abilene, a modest Victorian cottage. Dwight stands at far left.

14

the bulk of their pay going to meet family expenses.

Ida's was the managing genius of this arduous and varied enterprise. Each day had its precisely allotted work, a schedule beginning at dawn in the summertime and well before dawn in the winter. Each boy had his specifically assigned tasks, with assigned times for their performance. (Particularly obnoxious chores, such as rising at five o'clock on cold winter mornings to build a fire in the downstairs stove, were rotated so that no one had to perform them for more than a week at a time.) The family spirit, which Ida did more than anyone else to create, was such as to move each boy through an inner persuasion and discipline to do his job: it was a spirit of love for one another, of profoundly felt sense of obligation and responsibility, of absolute family solidarity in the face of a coldly indifferent, when not actually hostile, environment. But each boy also knew that if he shirked or played hookey he was liable to immediate, severe, and generally corporal punishment administered sometimes by his mother, more often by his father.

Thus was Dwight Eisenhower's daily life divided, during his boyhood, into definite segments of time—home-chore time, schoolroom time, recess time, home-study time, creamery-work time, bedtime—with only a severely limited amount of free time left over for passive pleasures or purely spontaneous play, for daydreaming or brooding introspection.

It was a regimen, along with a family spirit, well designed to develop the moral and practical sides of Eisenhower's character—especially as defined by the Protestant work-ethic ideal. Encouraged and trained to effective expression were his natural tendencies toward selflessness, patience, persistence, kindness, generosity, industry, cheerfulness, self-control, courage, along with a hard common sense and strong ambition. It was a regi-

men and spirit ill designed, however, to stimulate his aesthetic sensibilities or any natural inclinations toward artistic expression which we now know he possessed.

For though we have it on a great poet's authority that truth, goodness, and beauty are one, and though they may actually be identical in that realm of the ultimate where the poet dwells, they certainly do not present themselves so precisely in our ordinary worldly experience. Far from it. Indeed, in our experience they are sharply distinguishable from one another, so much so that moral goodness may approach us hand-in-hand with the most repulsive ugliness, and great beauty mask utter falsity and wickedness wholly depraved. Indeed, the bitter experience of beauty so conjoined is common enough so that a significant number of people in our society have felt a profound suspicion of whatever greatly charms the eye, even a flat rejection of all aesthetic joy as invariably being the agency of fraud if not a deceitful lure toward the soul's destruction. Clearly, then, an acute religious moral sense, far from being one with the finest aesthetic sensitivity and judgment, is often not even joined to it in anything like equivalent proportions within the same human being. He who possesses the former in fullest measure may be almost totally lacking in the latter. And this points directly to the fact that the ethical and the aesthetic in our daily lives require, for their recognition, appreciation, and human creation, the application of quite different scales of values, the use of quite different forms of judgment, the exercise of quite different faculties of mind and spirit. Rigorous logic and an accepted rigid standard for the measurement of virtue may suffice for the recognition of practical truth and moral goodness. They do not suffice for the appreciation of these in aesthetic terms—and they become almost irrelevant (though never wholly so) to the appreciation and creation of

that sensuous visual beauty with which the artist of brush and palette is concerned.

Santayana points out, in his *The Sense of Beauty*, that the distinction between the moral and aesthetic, or between the values exclusively proper to the two spheres in our ordinary experience, is to a considerable degree the same as that between work and play. The activities of the moral sphere, incited by outward challenge and molded from within by a stern sense of duty and obligation, are *useful* in that they serve, ultimately, the needs of self-preservation (racial preservation) against environmental threats, or serve a good that can be eventually defined in substantially economic terms. Viewed thus in the large, virtue is *not* its own reward. Moral value attaches to objects or acts only insofar as these are recognized as means to worthy ends and such value for the moral individual is in the nature of a pleasure deferred, a future glory, a bank draft to be cashed in heaven. In other words, virtuous activities are beneficial activities, and their virtue consists, in the last analysis, of their promise of some kind of future profit. The activities of the aesthetic sphere, on the other hand, are literally *useless*. Characterized by spontaneity and unalloyed delight, and wholly inward in their motivation, they are literally their own reward in that they serve no purpose beyond themselves, are their own *raison d'être*. Aesthetic value does not adhere to them, but is inherent in them, as beauty is in the object perceived as beautiful by our senses. ". . . in the perception of beauty, our judgment is necessarily intrinsic and based on the character of the immediate experience, and never consciously an idea of an eventual utility of the object," writes Santayana, whereas "judgments about moral worth . . . are always based, when they are positive, upon the consciousness of benefits probably derived." When they are positive! They are not often so. In the

(Continued on page 49)

In 1878 Jacob Eisenhower, his family and fellow members of a religious sect known as the River Brethren, came to Kansas from Pennsylvania. Although the family's traditional vocation was farming, Jacob's son, David, displayed no interest in that way of life. Instead, in 1885, with financial backing from his father, he opened a general store in Hope, Kansas, bearing the Eisenhower name.

16

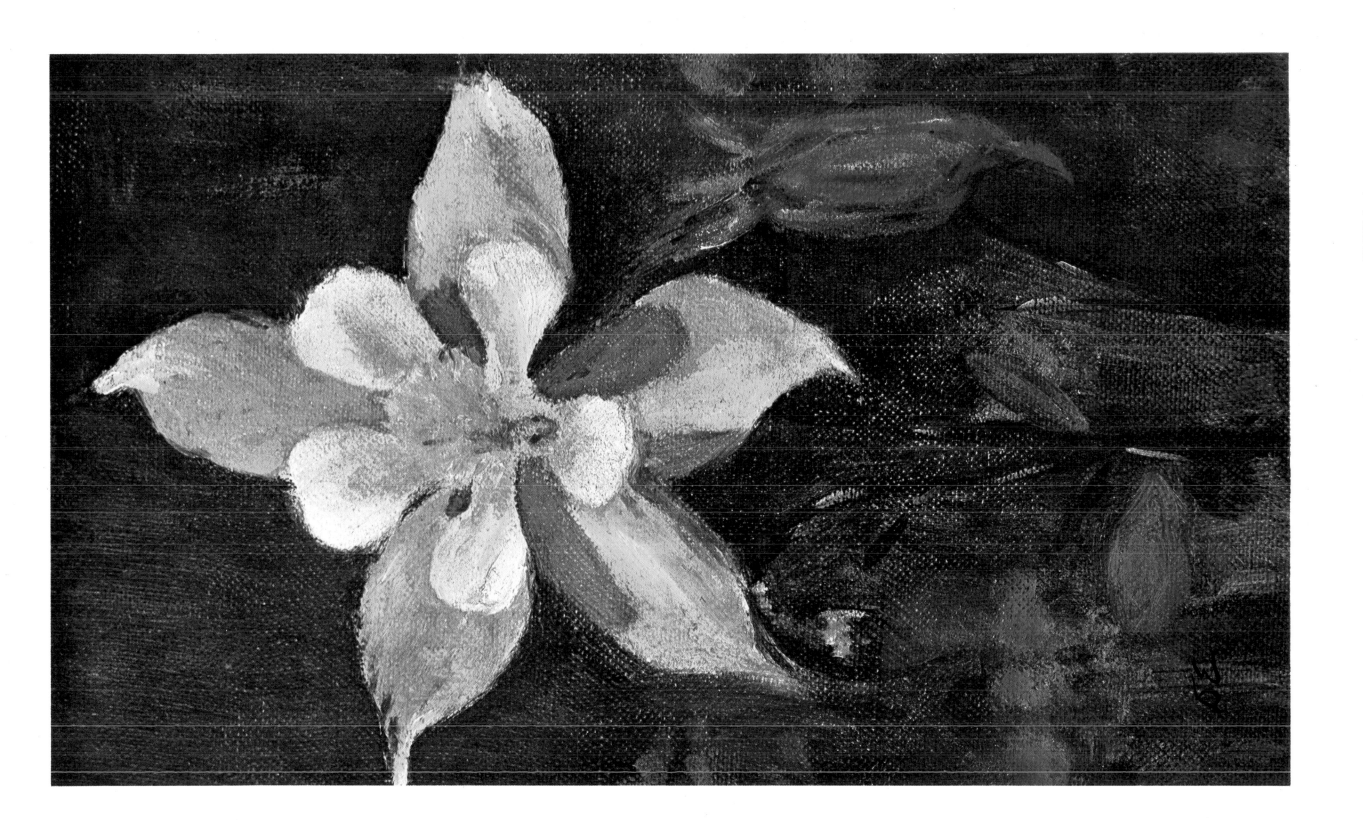

PLATE 1

COLUMBINE

From the collection of Mr. and Mrs. Aksel Nielsen, Denver, Colorado. The state flower of Colorado, *Columbine*, was painted in the late 1940s, one of the few floral studies he attempted. A thin application of dark paint to the background and foreground greenery concentrates attention on the fully opened blossom and pink bud. 11½ x 9½ inches.

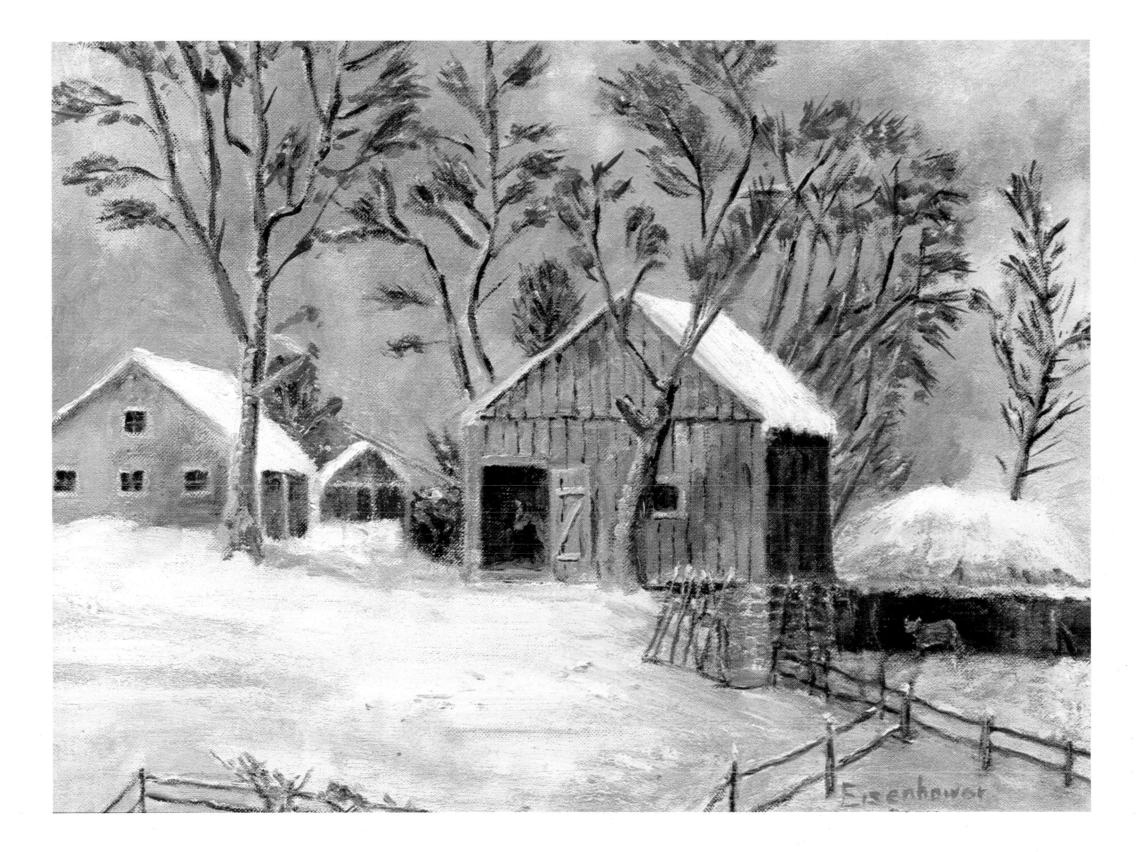

PLATE 2

BROWN FARMHOUSE AND OUTBUILDINGS

From the collection of
General Andrew J. Goodpaster.
The architectural detail of
identical square windows with
both the house and the
outbuilding seems to be more for
design than authenticity. An
otherwise stark sky has been
handled by daubs of green and
brown brushwork on the trees.
Painted in 1958.
12 x 16 inches.

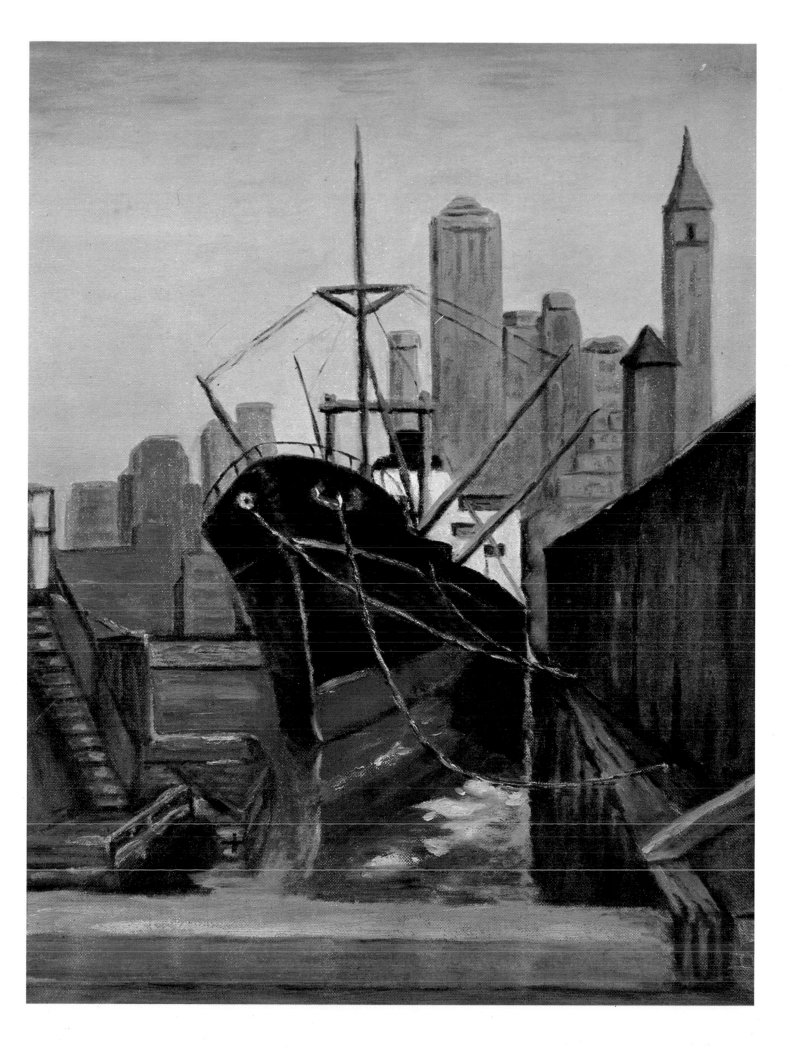

PLATE 3

SEASCAPE

From the collection of Field
Marshall Lord Alexander,
Berkshire, England. When Lord
Alexander was Governor General
of Canada (1946–1952) he and
General Eisenhower exchanged
paintings, Lord Alexander
acquiring this one. This probably
depicts New York harbor. It was
painted circa 1948. Eisenhower
later developed a more convincing
perspective of buildings and
other structures.
18 x 14 inches.

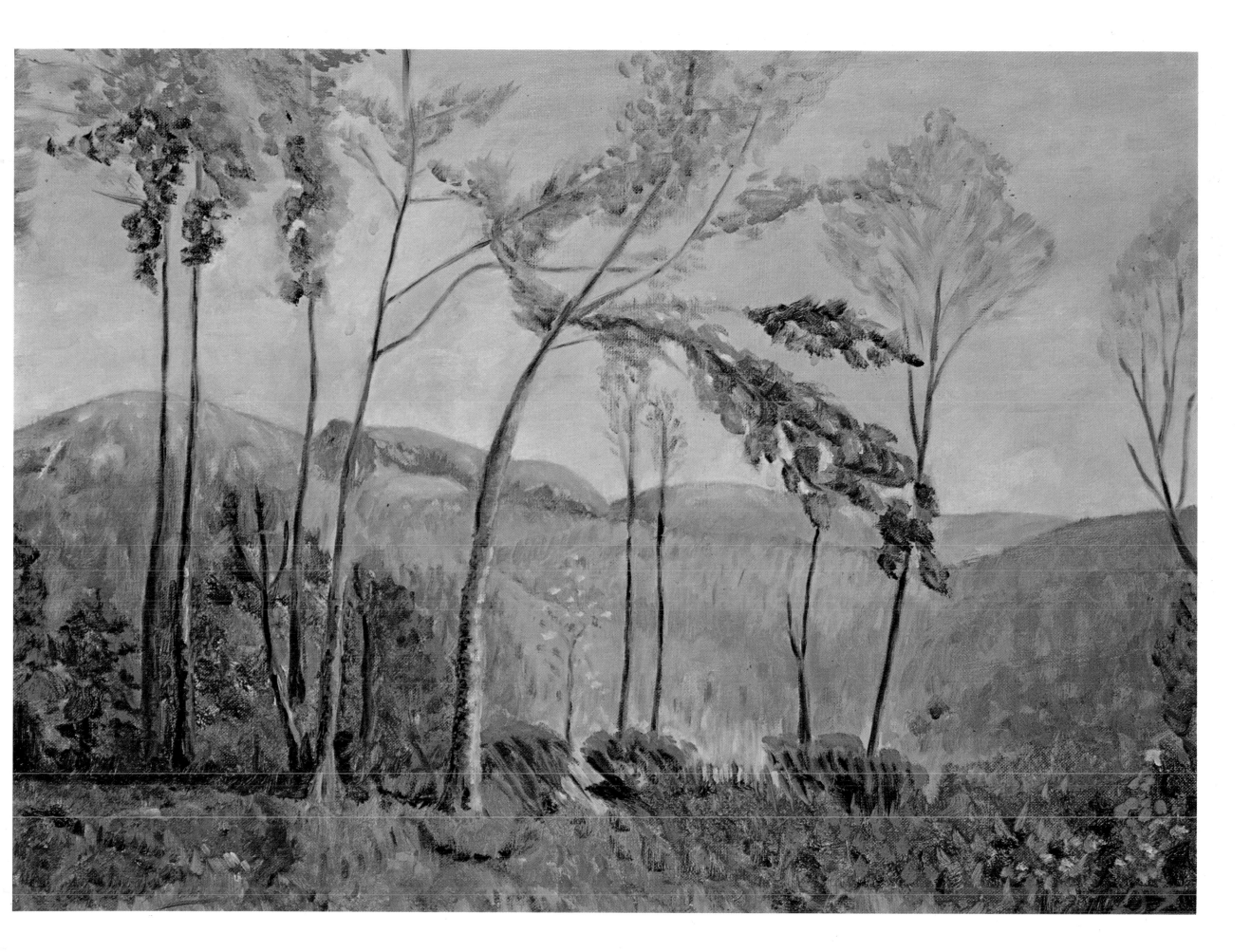

PLATE 4

MOUNTAIN VALLEY

From the collection of
Ambassador and Mrs. John S. D.
Eisenhower, Valley Forge,
Pennsylvania. The purplish
mistiness of a mountain range,
the placement of slender birch
trees and the detailed brushwork
of the immediate foreground
give distance to the composition.
Serenity pervades the painting.
18 x 24 inches.

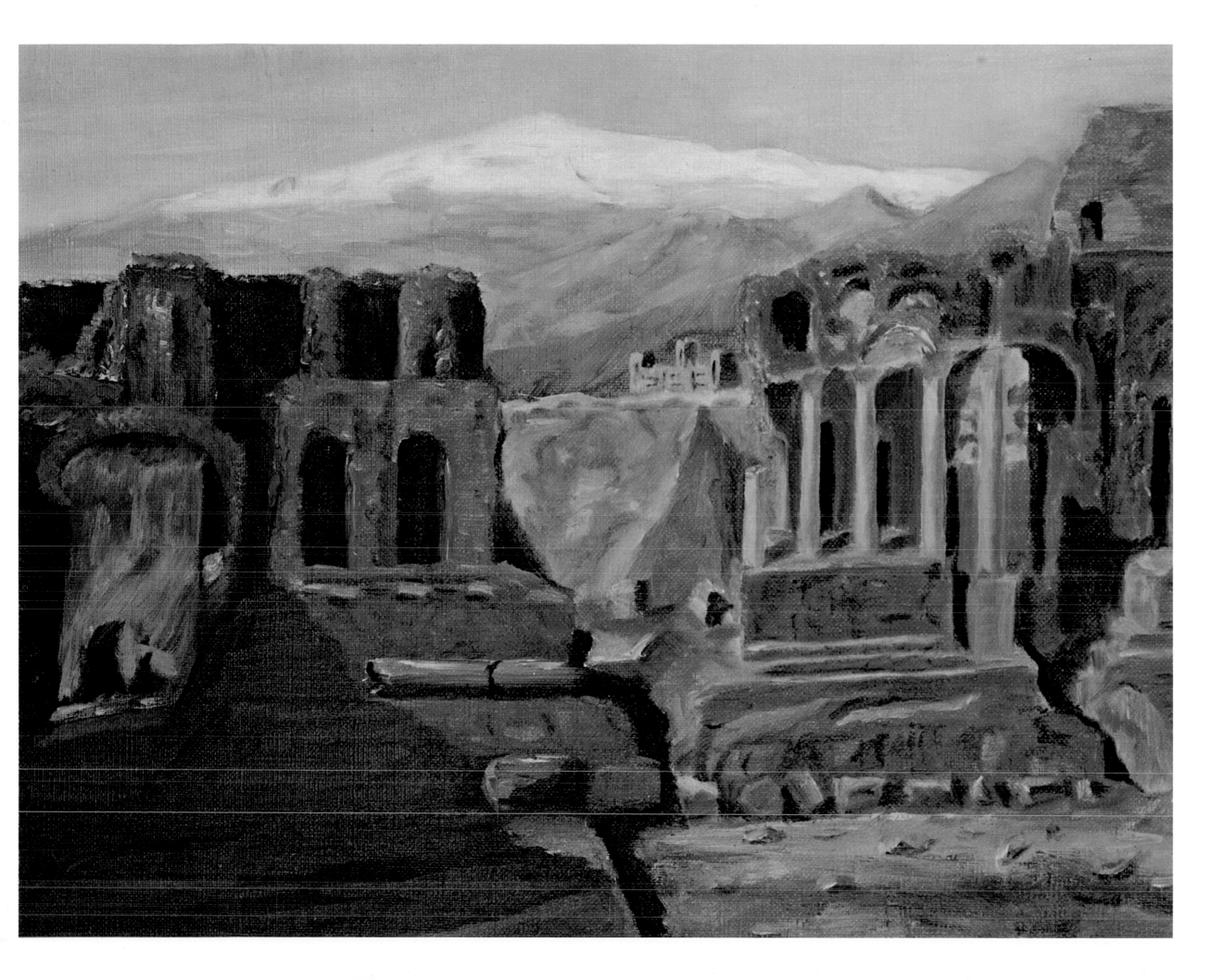

PLATE 5

MT. ETNA

From the collection of Mr.
and Mrs. William E. Robinson,
Greenwich, Connecticut.
Probably painted in 1951,
this one presents a more
close-range view of a subject
than most of Eisenhower's
paintings. The rich warmth
of brick-reds is dominant,
so much so that one is not
immediately aware of Mt. Etna
in the far background.
13 x 16 inches.

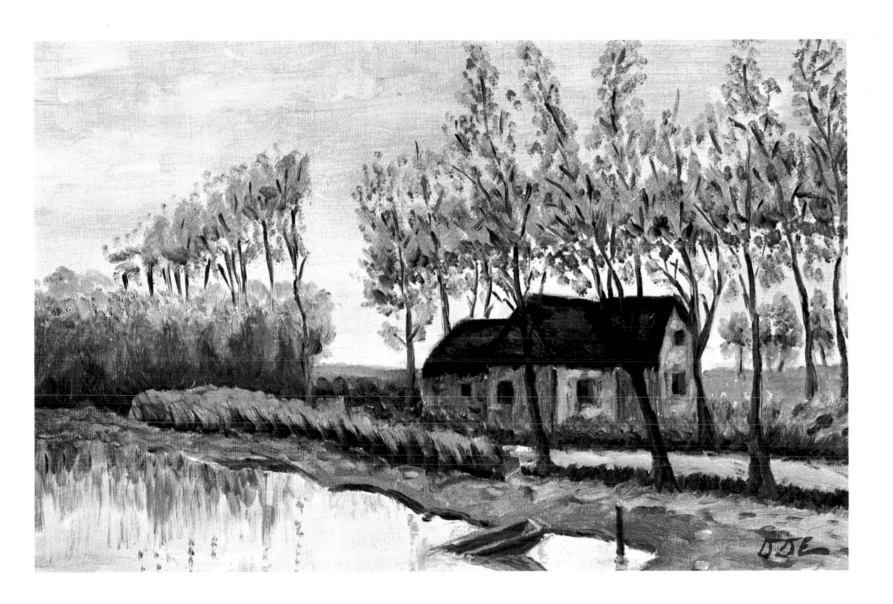

PLATE 6

NORMANDY SCENE

From the collection of
Brigadier General and Mrs.
Arthur S. Nevins, Gettysburg,
Pennsylvania. Painted in 1951
when Eisenhower was in command
of SHAPE, the lone cottage,
sparse, slender trees and open
terrain are typical of the
Normandy landscape Eisenhower
grew to know so well.
Whether recollected or copied from
another picture is not known
but such a scene very well
could have been vivid
in his memory.
13¾ x 18 inches.

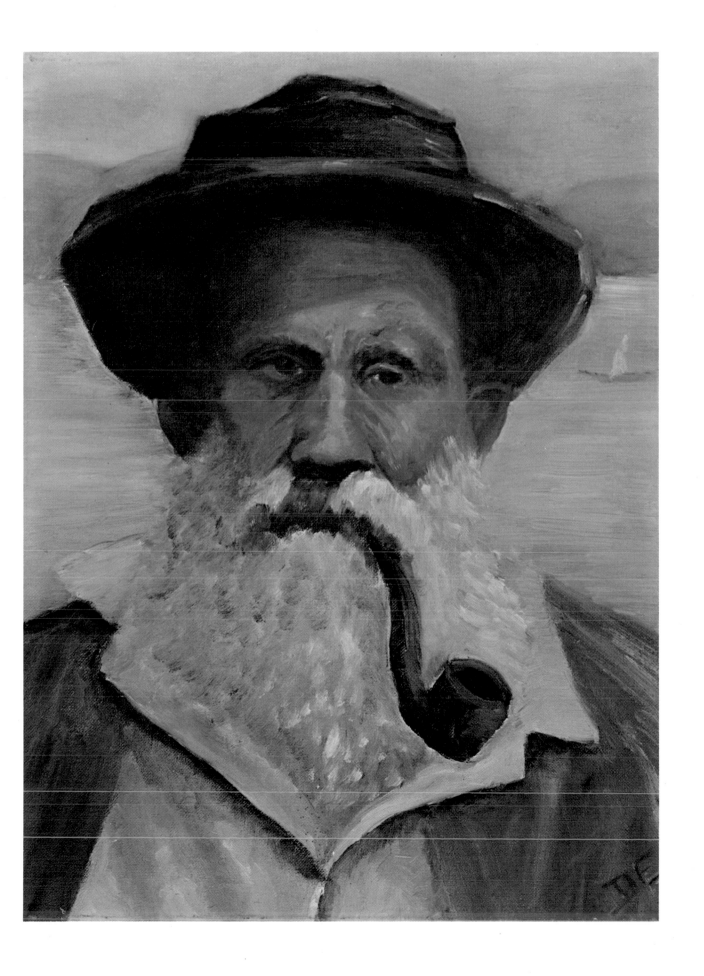

PLATE 7

BRITTANY FISHERMAN

From the collection of Mrs.
Paul T. Carroll, Arlington,
Virginia. The general presented
this study of a somber French
countryman, painted in 1952,
to the Carrolls in Marne la
Coquette, near Paris, after they
had admired it. Eisenhower
demonstrates his growing
effectiveness with color in his
contrast of the fisherman's
ruddy complexion with the
cold grayish-blue dampness
of the Brittany sky.
Framed, 20 x 16 inches.

PLATE 8

FORKED ROAD

From the collection of Mr. and
Mrs. Pollard Simons, Dallas,
Texas. The exact locale of the
landscape is not known. Possibly
only the forked roads inspired
the painter and the balance of
the composition was imagined.
His introduction of the vivid
red of the barn beyond the
starkness of bare trees
serves to stir in the viewer
a mental image of a warm
fire in a home beyond.
8 x 10 inches.

PLATE 9

ANN HATHAWAY'S COTTAGE

From the collection of Brigadier General and Mrs. C. Craig Cannon. Painted in 1951 when General Eisenhower was in command of SHAPE, this idyllic scene with thatched-roof cottage and a profusion of flowers is in sharp contrast to the bleakness of *Normandy Scene* (Plate 6), painted the same year. 25½ x 31¼ inches.

PLATE 10

BYERS PEAK RANCH

From the collection of Mrs. Virginia N. Muse, Denver, Colorado. When compared with his paintings of the Alps, one is struck with how typical the distant mountains in this painting are of Colorado and how imposingly typical are the Alpine renditions. The painter's fondness for tall, tapering trees is exhibited again, forming an interesting, centralized pattern. The use of yellow in the meadow and details of color relieve the broad expanse of the foreground. 17½ x 20½ inches.

PLATE 11

COLORADO SCENE

From the collection of Mr. and Mrs. John M. Burnham. The luminous yellow trees, near Central City, Colorado, were painted in 1952. The painting was presented to Mr. Burnham on Christmas Eve day the same year after he and Fred Waring had delivered a turkey from the Waring farm to the Eisenhowers. Mr. Burnham particularly praised this painting whereupon Eisenhower signed it with "D.E." and gave it to him. 18 x 12 inches.

PLATE 12

ST. JAMES PARISH WARWICK, ENGLAND

From the collection of
Mr. and Mrs. Aksel Nielsen,
Denver, Colorado. Eisenhower
must have delighted in placing
the two tiny priests on the
balcony above the archway,
as well as the two walking
on the ramp at right. He has
treated the perspective of the
diminishing turrets on the
left admirably. Great care
was used in color selection
for the stone masonry.
Painted in 1952.
29½ x 25½ inches.

PLATE 13

THE GETTYSBURG FARM BEFORE RENOVATION

From the collection of Mrs. Frances Doud Moore, Belaire Beach, Florida. Muted blues, tonalities of white and the total absence of warm colors give the painting a feeling of the raw chill of winter. This is a view of the south end of the original farmhouse at Gettysburg, Pennsylvania, before it was renovated and remodeled. Here the Eisenhowers spent many happy times together. Mrs. Eisenhower still makes her home there. 8 x 10 inches.

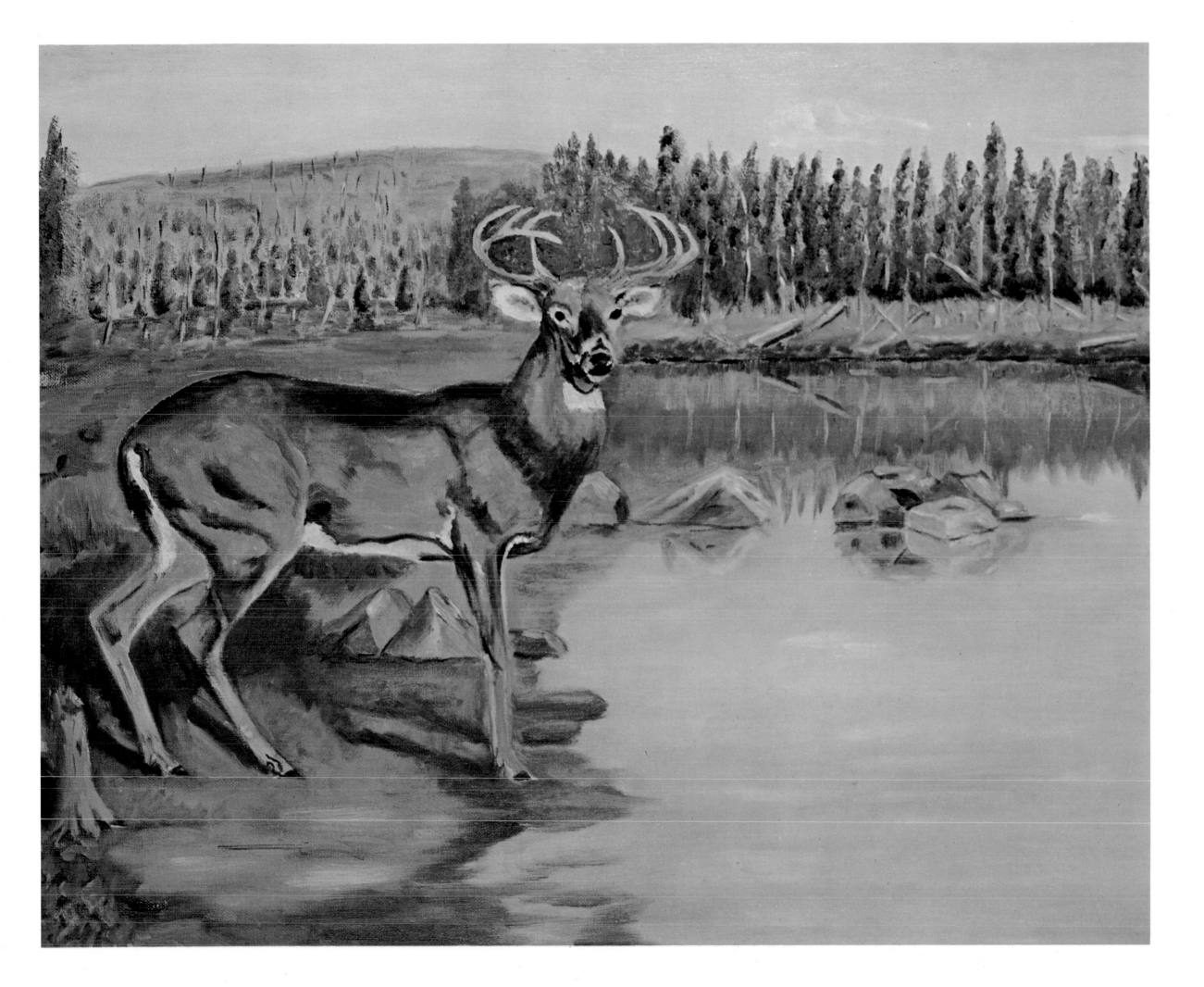

PLATE 14

DEER AT WATERING POND

From the collection of
Leonard D. Dry. Once again
Eisenhower experiments with a
variety of reflected images
in water. There is exceptional
modeling of the deer for a
self-taught artist who
received no formal training
in drawing or painting. This
painting was done in 1952
when the general headed SHAPE.
26 x 30 inches.

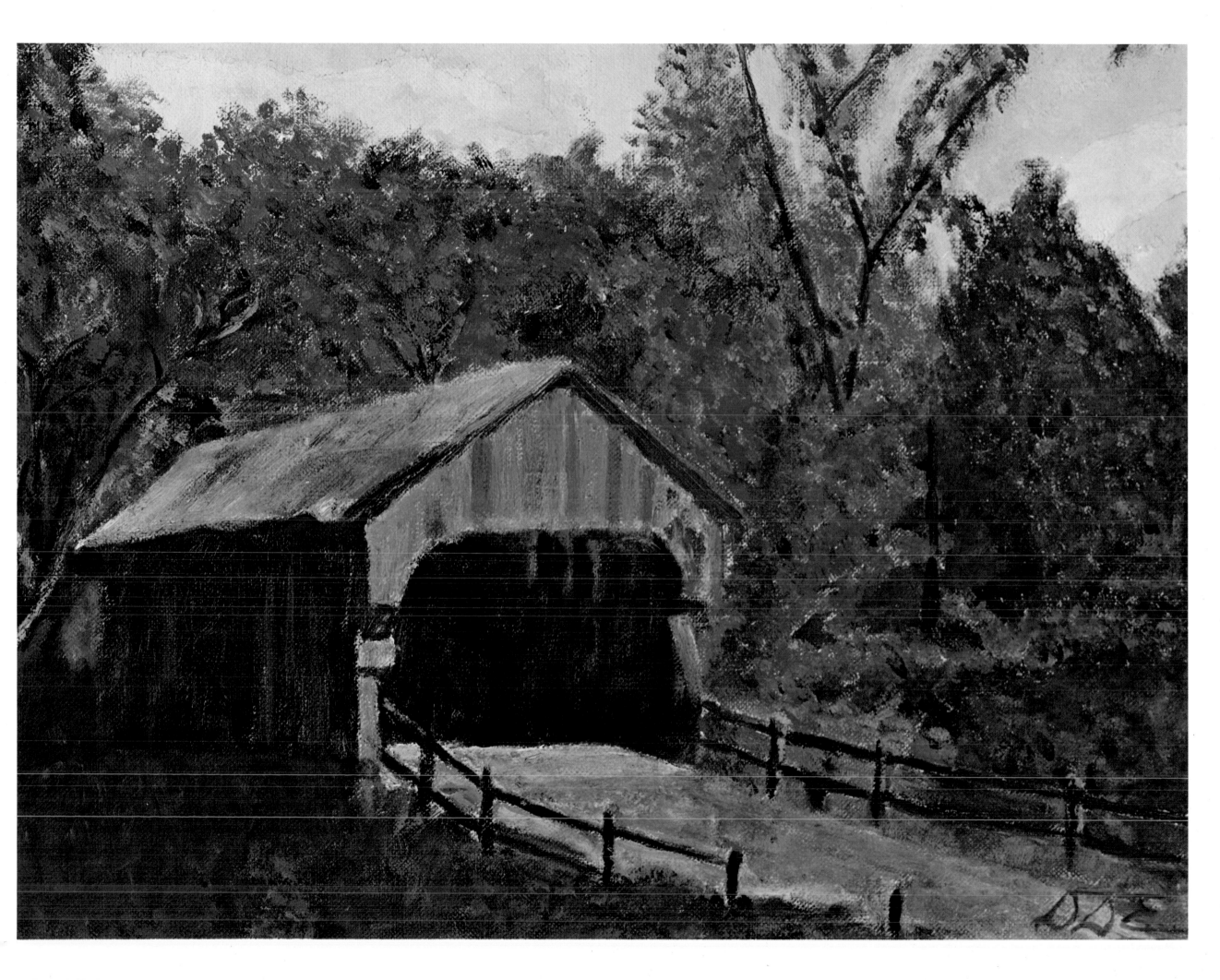

PLATE 15

COVERED BRIDGE

From the collection of Mr. and
Mrs. George Allen. This landscape
is probably one of Eisenhower's
later works, for although the
subject is characteristic of his
paintings, there is a notable
development in his use of contrast,
color and texture. The eye follows
the lightness of the sky as it is
reflected on the roof and front of
the bridge and down along the
walk. Splashes of vibrant
red-oranges and yellows brighten
and unify the entire composition.
Rich and varying textures
evoke the feeling of fall as this
painting nearly comes to life.
12 x 16 inches.

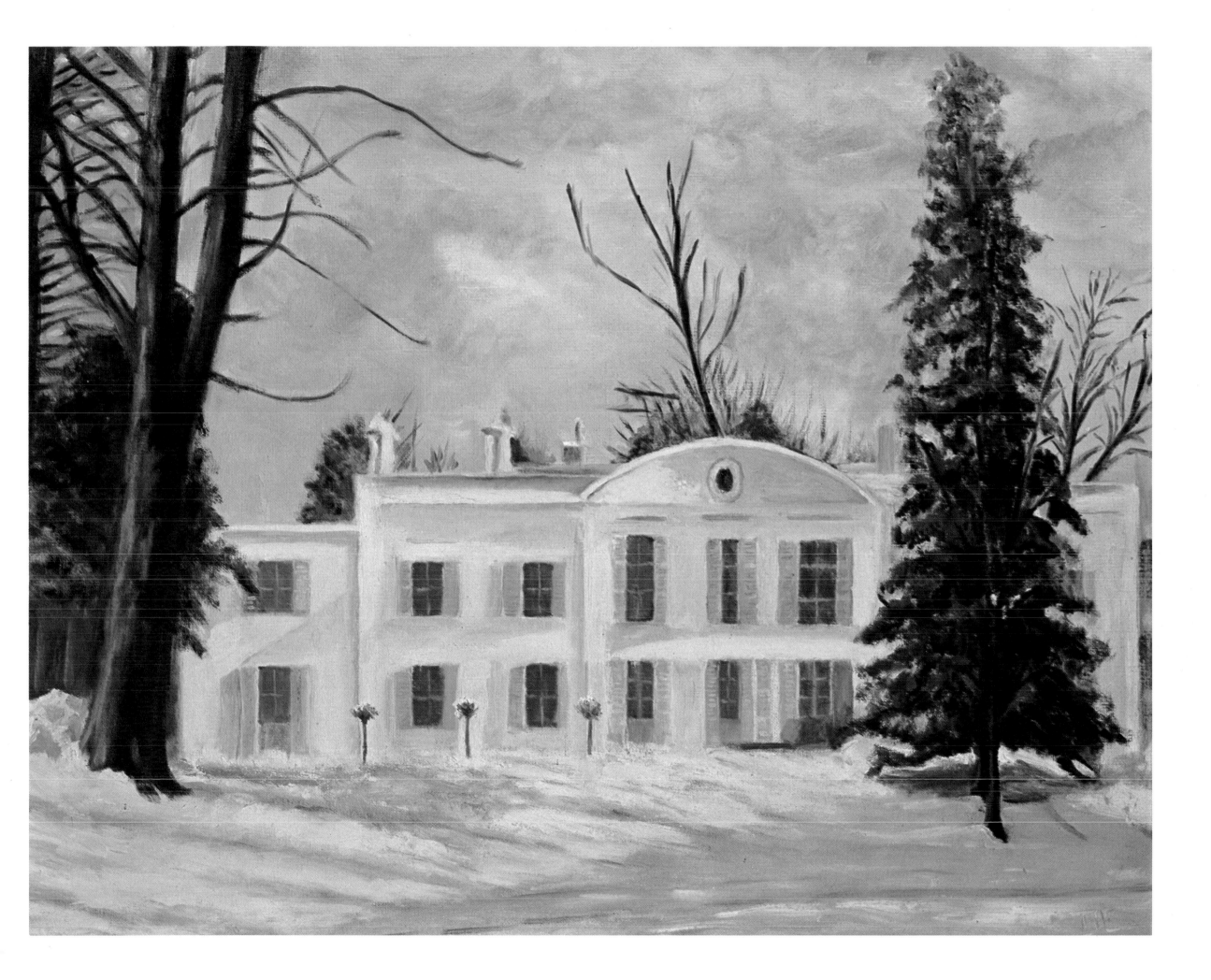

PLATE 16

4 RUE ST. HONORÉ, FONTAINE-BLEAU, FRANCE

From the collection of
General and Mrs. Lauris
Norstad, Toledo, Ohio.
The home was occupied by
the Norstads 1951–1953.
Eisenhower painted it in
1952 when he was Supreme
Allied Commander, Europe.
When the Eisenhowers were
guests of the Norstads, he
sketched the residence, then
completed the painting at the
Supreme Commander quarters
at Marne la Coquette.
26 x 30½ inches.

main, moral judgments are negative—they are perceptions of evils to be avoided—and this is another aspect of the distinction between them and aesthetic judgments, which are mainly positive and perceptions of goods (pleasures) to be sought out and embraced.

Do we denigrate art and the aesthetic experience to the extent that we identify them with play? Not at all, says Santayana, who refuses to accept the common notion that only work can be "essentially serious" in the sense of being important, that play in all its varieties is "essentially frivolous" in the sense of worthlessness. "To condemn spontaneous and delightful occupations because they are useless for self-preservation shows an uncritical prizing of life irrespective of its content," he writes. "For such a system the worthiest function of the universe should be to establish a system of perpetual motion. Uselessness is a fatal accusation to bring against any act which is done for its presumed utility, but those which are done for their own sake are their own justification." Hence, though it is true that the "appreciation of beauty and its embodiment in the arts are activities which belong to our holiday life," as Santayana says, this means simply that they are the activities of genuinely free men, men not driven by outward need nor coerced by alien forces, men "redeemed . . . from the shadow of evil and the slavery of fear" and able therefore to follow "the bent" of their nature "where it chooses to lead. . . ." It is precisely through such activities that human life becomes most truly, intensely human, most sharply to be distinguished from life in its lower animal forms. And the expressive fruits of such activities, far from being mere adornments, are of the essence of civilization, and of humanity. They are ends, not means. They are that toward which a society aims, if often unconsciously, as it struggles to civilize itself.

But it would be difficult to imagine a philosophic outlook and a vital attitude more widely different from Santayana's than that of the Eisenhowers of Abilene. Santayana's was the aristocratic temper of a Spanish grandee and a Boston Brahmin fused into one—urbane, aloof, disdainful of popularity; the Eisenhowers were earthy, of the people as they were of the earth, and they were as invincibly democratic in daily practice as they were in theoretical commitment. Santayana's was the irreligious skepticism of an avowed materialist (although he wrote in a sonorous poetic style more congruous, one would have thought, with romantic idealism); whereas the Eisenhower parents were profoundly pious folk who imposed upon their increasingly unwilling sons frequent and lengthy sessions of Bible reading and fervent family prayer. Santayana's somberly poetic soul, long after he had lost his Christian faith (indeed, until he died), was nourished by the rich aesthetic quality, the ritual beauties of sight and sound of the Catholicism in which he was raised. No similar nourishment came to Dwight Eisenhower as a boy or man. Historically, the Eisenhower family religion was the most bleak and austere, and the most hostile to aesthetic enjoyment and expression, of all the fundamentalist varieties of Protestantism.

It was a religion rooted in the teachings of Menno Simons, who, in Zurich in 1528, first proclaimed his "rediscovery" of "true Christianity" after the centuries of organized distortion and corruption of Jesus' teachings. The whole sacerdotal idea —the idea that a divinely authorized priesthood was required to serve as intermediary between God and the individual Christian—was repudiated by Menno Simons. There was no authority, said he, outside the Bible and the enlightened conscience of the individual. Hence the Church of Rome did not have a Christian character. It was a non-Christian support of a non-

Christian civil authority and, though all true Christians should obey the lawful requirements of "an alien power" (one must render unto Caesar the things that are Caesar's), no true Christian could be a member of the Church of Rome or otherwise compromise with the world. He must, instead, follow the dictates of his own conscience. The Eisenhower forebears, at that time living in the Palatinate of Bavaria, were among the earliest to be converted by this teaching. They suffered religious persecution, in consequence, during the devastating Thirty Years' War (1618–1648) and fled to Switzerland, where they remained as a family for about a hundred years; they then moved to Holland whence, between ten and twenty years later, they sailed for America settling in Pennsylvania which is still the home of many Mennonite groups.

Volume I of *Pennsylvania German Pioneers* records that among the Palatines who arrived in Philadelphia on the ship *Europa,* sailing from Rotterdam in 1741, were Hans Nicol Eisenhauer [*sic*], Johan Peder Eisenhauer, and Johan (x) Eisenhauer, and that on the day of their arrival, November 20, they took oaths of allegiance to the government before one Ralph Assheton, Esq., at the Philadelphia courthouse. Soon they settled on or near the Susquehanna River with a colony of coreligionists who, because of their location, became known as the River Brethren and whose descendants, more than a century later, in 1862, officially established themselves as the Church of the Brethren in Christ. By that time the spelling of the family name had been long accepted as "Eisenhower" and Dwight Eisenhower's paternal grandfather, the Reverend Jacob Eisenhower, a Brethren minister, was living as a prosperous farmer on the outskirts of Elizabethville. He it was who brought the family to Kansas as part of a River Brethren colony that settled in Dickenson County in 1878–1879, a colony characterized by A. T. Andreas in his *History of the State of Kansas,* published in Chicago in 1883, as "one of the most complete and perfectly organized . . . that ever entered a new country." The Reverend Jacob Eisenhower was one of its principal leaders and organizers.

The Kansas Brethren, like other Mennonites, though less extreme than the Amish and Dunkards, remained committed to nonconformity with the world. They were profoundly conservative in all things, clinging stubbornly to old ways of dress and speech and farming. (They were soil conservationists in an era when many who moved westward with the frontier were boasting of the number of farms they had "worn out.") Most of the Brethren continued to dress as they had when they lived along the Susquehanna, the men in dark plain suits with shallow-bowled black felt hats, the women in long plain dark dresses and little white bonnets indoors, and large black bonnets outdoors. Pacifism, the refusal to bear arms or support a military establishment, was at the core of their religious tradition, and they continued out-of-step with a world that remained extravagant, intemperate, and violent. Certain ambiguities appeared, at least to alien eyes, within the general consistency of their beliefs. They were an intensely clannish lot, vividly conscious of themselves as a community distinct and separate from the larger one in which they were obliged to live. But they were also intensely individualistic. They insisted upon a greater degree of personal privacy than was common among the populace at large; insisted upon absolute privacy of conscience, in accord with their belief in each man's distinct and unique relationship with God; and to maintain themselves outside the official community, for all their other- and anti-worldliness they laid great stress upon the morality of hard work, of economic self-determination, of economic self-reliance, a morality

whose aim was the accumulation of worldly goods. Some Mennonite communities were literally communistic, holding all goods in common. The Brethren of Dickenson County were strongly, even religiously committed to private property, as if its effortful accumulation were an act of piety and its possession a mark of God's favor. They became known to their neighbors as "close" and "shrewd" in their business dealings, though their word, once given, was their bond.

This background made David Eisenhower's business failure additionally traumatic for him—to the pain of loss, of wasted effort, was joined a sense of guilt, the guilt of impiety—which, in turn, may have led him or driven him toward the murky realms of mysticism in which he began to be involved during his Texas exile, and toward a for_____ ity that was more rigid even than th___ _____ _____ raised. (By 1911, the ye___ _____ _____ West Point, David ___ _____ known as Jehova___ _____ avid's bitterly un___ _____ aded, by whom w___ _____ i Smyth, late Astr___ _____ rs of the Great Py___ _____ ramids nearby w___ _____ uilded better tha___ _____ rough many long___ _____ wall chart, cover___ _____ h the three pyram___ _____ with the lines of ___ _____, and inner passageways ___ _____ to produce allegedly profound sym___ _____ ngs. David believed that the pyramids, thus "interpreted," predicted biblical events that occurred long after the pyramids were finished, and he later showed

his fascinated three elder sons in what manner, in his belief, they did so. Significantly, this was the only original "work of art" that hung upon the walls of the home in which Dwight Eisenhower grew up.

Nor did the future general and president gain aesthetic experience, as a boy, from any other expression of his parents' religious fervor. He had no ear for music—was notably tone-deaf, as was widely remarked by his associates in later years when he roared out the ballads whose words and rhythms intrigued him—and so could have derived no aesthetic pleasure from his mother's playing of hymns on her piano even had these been of surpassing beauty. In the rhythms and intonations of his parents' vocal worship at home there was nothing that aroused any emotions in him save those of patient resignation, and these often enough gave way to a covert irritability of the impatience and frustration of a boy. He was simply bored to distraction by the sessions of family Bible reading and prayer; and the Sunday church services were, from his point of view, little better.

In sum, his boyhood experience of religion was a design wholly stripped of the vibrancy and color and attention-grabbing interests of the "real" world. He was too young to see the beauty in a pure (puritanical) abstraction, a schematic outline in unrelieved black and white, with lines far too straight and angles far too sharp to define for him any form of beauty; and its effect upon him was almost precisely opposite to what his parents intended. He reacted against it. So did all his brothers, each in his own way. Through most of his adult life, Dwight Eisenhower had no religious affiliation whatever and rarely so much as set foot inside a church. It was not until he was president-elect—and largely then, one suspects, for the purpose of "setting an example"—that he became a Presbyterian.

THE EARLY YEARS

Very different from the home and family influence upon Dwight Eisenhower as boy and youth was the cultural influence exerted by the town of Abilene. The difference was great enough to amount, in some respects, to a flat contradiction. It did not include, however, any effective emphasis upon the aesthetic as distinct from the moral side of his character. Instead, it served on the whole to confirm him further in mental attitudes and ways of life that were indifferent if not actively hostile to artistic pursuits.

When the westward-building Kansas Pacific Railroad reached Abilene in 1867, just ten years before the arrival of advance agents for the River Brethren colony, Joseph McCoy at once established his huge stockyards in what had theretofore been a tiny hamlet, slow of growth, quiet of life, and wholly unknown to fame. Abruptly, all was changed. Abilene became the only market outlet for millions of longhorn cattle, driven northward on the Jesse Chisholm trail across a thousand miles of Texas, Oklahoma, and southern Kansas. Months of the hardest kind of labor intervened for cowboys, between the roundups of these vast herds and their arrival at the railhead; and once this long trek was completed they, a rough and lawless group at best, "let go" with a vengeance. Facilities for their doing so were abundantly provided in a collection of twenty-five or thirty one-story frame buildings, each with ten to twenty rooms, hurriedly erected in what was officially known as "McCoy's Addition" and unofficially as "Hell's Half-Acre," a mile and a half north of Abilene's main street. Here saloons, gambling halls, and whorehouses, operating night and day, invited vicious fistfights, shootings, and knifings—a daily, sometimes almost an hourly, occurrence.

For many months no effort at all was made to curb this lawless violence. None could be made, legally, until Abilene was

Dwight (first row, second from left) and his fifth-grade classmates pose in 1900 for a class picture. Ike completed his first six grades in this single building—Lincoln School in Abilene.

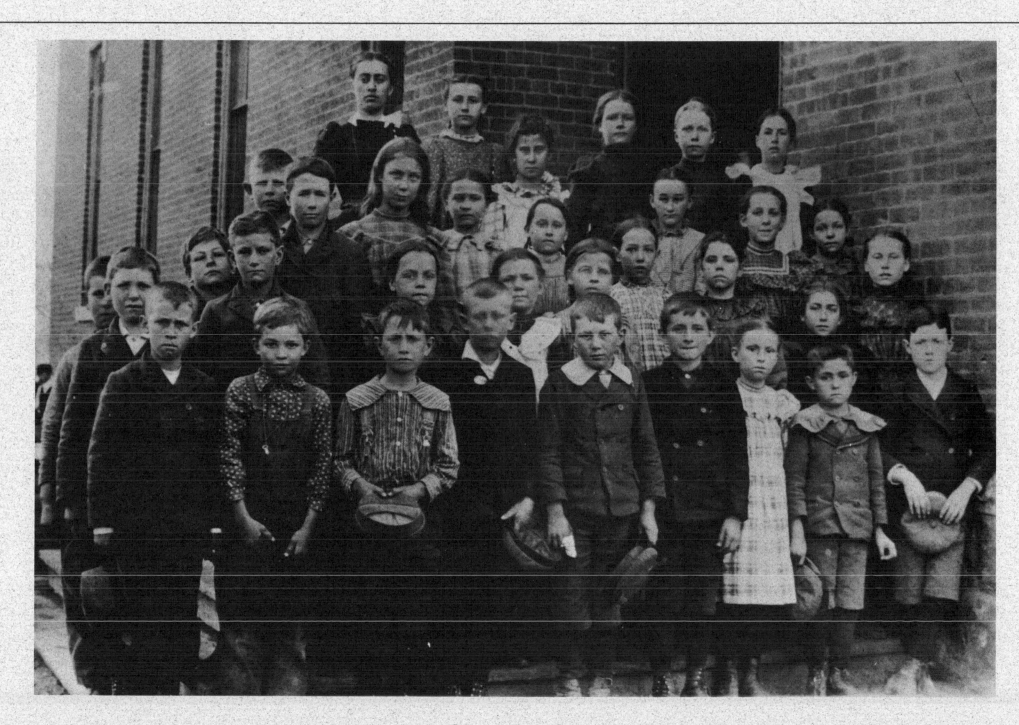

53

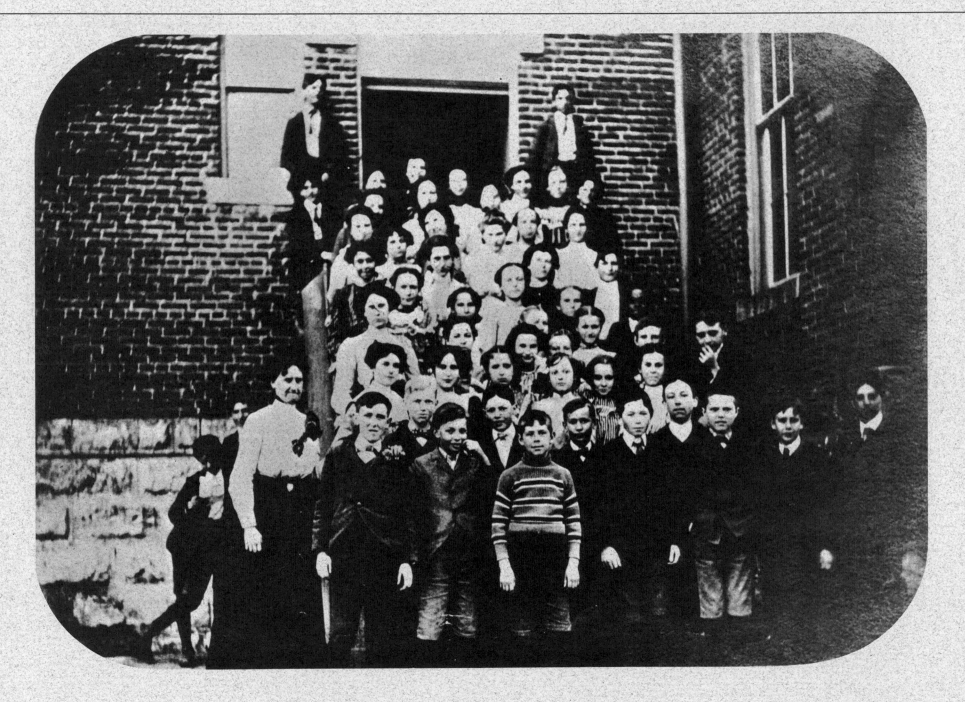

incorporated as a town in 1869. And for months after that nothing actually effective was accomplished: all the first town marshals held office very briefly, their tenure ended by forced flight or by incapacitation through violent assault. Then, from Kit Carson, Colorado, came one Tom Smith, a soft-spoken man of great courage and moral force who, by his strength of character as much as by his superb fighting skill, managed to curb the violence and enforce the recently adopted ordinances against the carrying of firearms and for the licensing of saloons, to a greater degree than ever before. He became a legendary hero of the Old West, and his successor, James Butler (Wild Bill) Hickok, became an even greater one. Wild Bill claimed to have killed forty-three men by the time he accepted the job of Abilene town marshal, not counting those he had killed as a sharpshooter with the Union Army during the Civil War; and in Abilene he soon demonstrated an awesome, fearsome skill with six-shooters (he wore one on each hip), drawing and shooting with marvelous speed and accuracy, and with either hand. Legend has it that, in Abilene, he once killed two men who drew on him simultaneously from either side; he was said to have drawn and fired with such rapidity that a boy witness swore he heard but a single shot. Another story, fabricated by the marshal himself but integral to his legend, had him fighting singlehanded a gang of ten vicious desperadoes and killing every one of them.

Abilene's years as the wildest cowtown on the Wild West frontier were very few. The trail-weary, pleasure-starved, gun-toting cowboy and those lawless elements which fed upon the cowboy's needs and wages moved westward as the railheads moved, bestowing upon successive High Plains towns, notably Hays and Dodge City, the lurid notoriety that had initially belonged to McCoy's Addition. By the time David Eisenhower

In 1902 Dwight entered Garfield Junior High on the north side of Abilene. Here he is pictured (third from left) with his seventh grade class.

first saw Abilene the town was a quiet, law-abiding community with several churches and no open gambling halls or saloons. But the gawdy cowtown legend and a resultant tough combative Wild West tradition remained vividly alive in Abilene and continued to do so, was indeed a ruling cultural force in Abilene's boyhood world, through all the years of Dwight Eisenhower's growing up. It strongly influenced him in ways counteractive to the pacifistic religious teachings of his home.

A continuing game for the Eisenhower sons throughout their childhood, engaged in whenever their school and work regimen and their sports activities permitted, was "Wild West." In their backyard and barn, in the alleys and vacant lots of the town, across the wide pastures beyond the last house, along the wooded banks of Mud Creek and the Smoky Hill River, they acted out sanguinary tales of Indian battles and of lawmen (Wild Bill Hickok and Bat Masterson were featured) shooting it out with badmen. (Western novels on the order of Zane Grey's and Western pulp magazines remained Dwight Eisenhower's favorite reading for relaxation when he was Supreme Commander; they were shipped to him from America "by the bail," according to his naval aide, Captain Harry C. Butcher.) And sanguinary in reality, more so than in most mid-American towns at that time because of the local Wild West tradition with its emphasis upon the daring and skills of violence, were the fistfights in which Abilene boys engaged on frequent occasions. Often these fights did not end until one of the combatants was stretched unconscious on the ground. Both Arthur (the eldest of the Eisenhower sons) and Edgar fought such battles. Arthur did so twice, knocking out his opponent in one case and being himself knocked out in the other; while Edgar had a famous fight with a boy named Davis from the "snooty" North Side, a boy so much bigger and taller than he that Edgar could not reach his enemy's face with his fists until a savage body-pounding had bent the other over, whereupon Edgar smashed lefts and rights to the jaw until Davis collapsed, senseless. Dwight himself had many a bloody bruising fight with Edgar and was invariably beaten, for Edgar was not only older but considerably heavier for his age than was Dwight.

Ida, for all her pacifism, refused to intervene in such disputes, even when they occurred before her eyes. "You can't keep healthy boys from scrapping," she said. "They have to get it out of their system." She seems to have believed that Dwight needed such chastening to teach him self-control, for he had a ferocious temper, worse than any of the other boys, and was sometimes inclined toward a violence whose results might have been fatal. For instance, once, in a fit of anger, he threw a brick with all his might at Arthur's head, a lethal missile which the older boy barely managed to duck in time. And it was Dwight, not Edgar, who would figure, at age thirteen, in what elderly Abilene citizens, forty years later, would remember as "the toughest kid fight" they had ever seen. His opponent was a boy named Wesley Merrifield, acknowledged champion of the North Side, who greatly outmatched him in weight and fighting skill and who gave him a severe beating for a far longer time than most "kid fights" consume. But Dwight wouldn't quit, and Merrifield couldn't knock him out, and so the struggle went on for more than two hours at the end of which time an exhausted Merrifield allegedly said, "Ike, I can't lick you," and an exhausted Dwight allegedly said, "Well, Wes, *I haven't* licked you." From that encounter Dwight staggered home so badly battered that he was unable to return to school for three days. (He was then attending Garfield Junior High, across the tracks in the "enemy" country of the North Side.)

In general, the Abilene town influence, insofar as it counter-

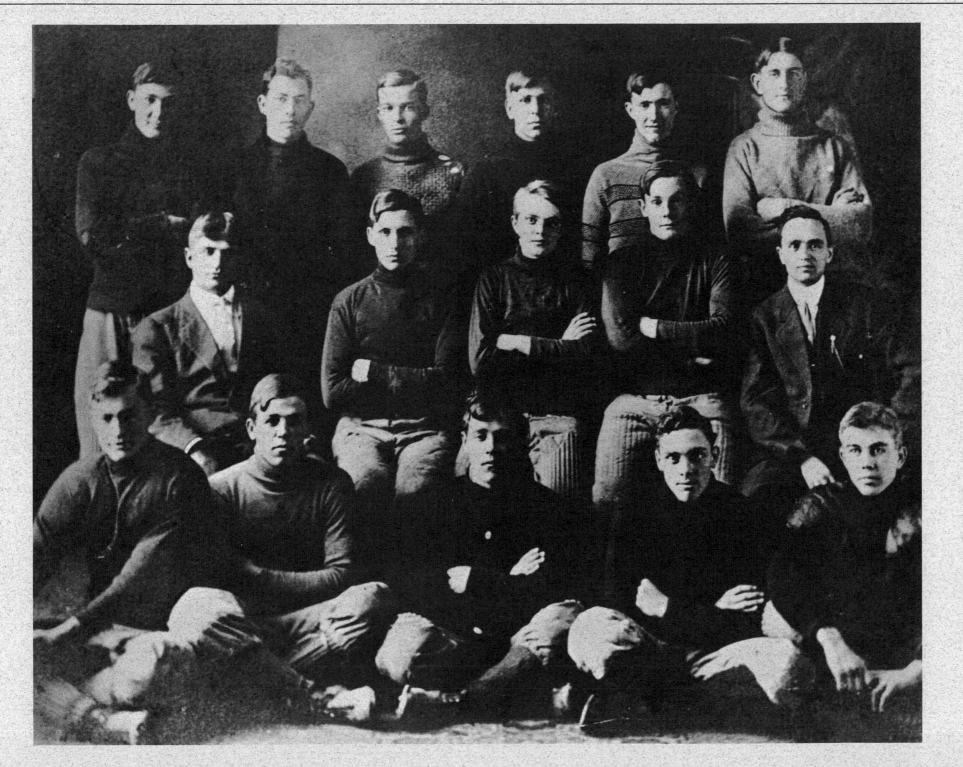

acted the influence of River Brethren doctrine and practice upon the Eisenhower boys, did so in ways that encouraged pragmatism, externalism, practical action—the physical instead of the spiritual aspects of life. It did nothing to encourage the cultivation of those contemplative solitudes in which great art dreams are born or point the way toward any sensitive appreciation of the fine arts, which received short shrift, one must add, in the public schools of that time and place. Certainly Dwight Eisenhower devoted none of his work-free time to passive and solitary pursuits. He was intensely physically active. Decades later he explained that he was a messy painter whose frustration was complete whenever he tried for anything delicate because, as he wrote: "My hands are better suited to an ax handle than a tiny brush." He also wrote that the only defect of painting, for him, was that "it provides no exercise. I've often thought what a wonderful thing it would be to install a compact painting outfit on a golf cart." As an Abilene youth, nearly all the considerable energy he had left over from the performance of his duties was absorbed into organized sports.

He played baseball. He played center field behind a southpaw pitcher named John "Six" MacDonnell, whose nickname had been acquired one day in the autumn of 1903 when Dwight, with other pupils of Lincoln and Garfield schools, received one of his few Abilene exposures to art. A traveling "art exhibit" had come to town that day and all grade and junior-high pupils were taken to it by teachers who released them from the normal study schedule. The exhibit was a collection of reproductions of famous paintings, sent out on tour from Topeka, the state capital. Among them, inevitably, was Raphael's *Sistine Madonna*. To Abilene schoolchildren, "Sistine Madonna" sounded like "Sixteen MacDonnell;" and so MacDonnell became "Six" forever after. The aptness of the cogno-

The sports-minded Eisenhower was the originator and first president of Abilene High's Athletic Association in 1908. In the same year he played right end for the school's football team (top row, third from left).

56

men was confirmed when recognition of the boy's prowess as pitcher coincided with the greatest fame of Christy Mathewson, whose amazing fastball ultimately won him 372 major league games and who was dubbed the "Big Six" because the smooth power of his throwing arm was likened to the then epitome of smooth machine power, namely, the six-cylinder motorcar.

Dwight Eisenhower played football. He played at end position in his earlier high school years (not being considered fast enough for the backfield nor heavy enough for the inner line) and at tackle when, in 1909, he returned for "graduate work" in the high school in preparation for West Point entrance examinations. In this normally unspectacular position he managed to star during a game with neighboring Salina that fall. Six MacDonnell, who had become one of Dwight's closest friends, was playing quarterback and, in a passing play, Six was viciously tackled and briefly knocked unconscious after he had thrown the ball. Dwight believed the injury to have been deliberately inflicted. He was enraged. He thereafter opened one hole after another for Abilene off-tackle plays, broke up one Salina play after another with his charging tackles, and had "roughed up" a good half of the Salina team before the game ended.

From all this the inference seems more than probable that teen-aged Dwight Eisenhower, if examined on the matter, would have indicated that the painting of pictures was a rather "sissy" occupation, in his opinion—a natural enough occupation for girls but unnatural to the point of being "queer" in a healthy American boy or man.

Perhaps he would have been somewhat more inclined toward such occupations, at least as an amusement, had the landscape of his boyhood been of the obviously "pretty," "grand," or "picturesque" kind which popular taste then decreed to be the *only* kinds suitable for artistic reproduction. His untrained eye and flickering attention might then have been caught and held by some particular beauty of scenery—by a waterfall sparkling in morning light, a mountain peak glowing with sunset colors, a sedge-fringed lake trembling in silver moonlight, a forest pool somberly reflecting giant boulders and towering pines—and out of the vision and the attention thus focused might have come an active desire to capture this striking beauty, to shape a tangible remembrance of it or of the emotion it evoked, on drawing paper or canvas. But there are no mountains in Kansas. There are no forests, no natural lakes of any size, no waterfalls more than twenty feet or so in height, not even any really great hills. And in the immediate environs of Abilene the view is likely to strike even the most sympathetic eye as less distinctive, less interesting, perhaps, than that common to several other areas of the state.

What Dwight Eisenhower said goodbye to on an early June morning in 1911—as he gazed out a Union Pacific train window, with an already nostalgic vision as the train gathered speed beyond the outskirts of his hometown, carrying him eastward on the first leg of his journey to West Point—was a countryside in which the "two Kansases," as William Allen White used to call it, meet and mingle in a way that subtract from each a good deal of the visual interest that each has in its "pure" form for those with eyes to see.

Immediately ahead of him as the train sped toward Kansas City lay eastern Kansas—a country of sufficient rain to sustain a richly diversified agriculture (corn as well as wheat, hogs and dairy cows and also sheep and beef cattle), with river valleys of immensely fertile soil stretching two to five miles wide

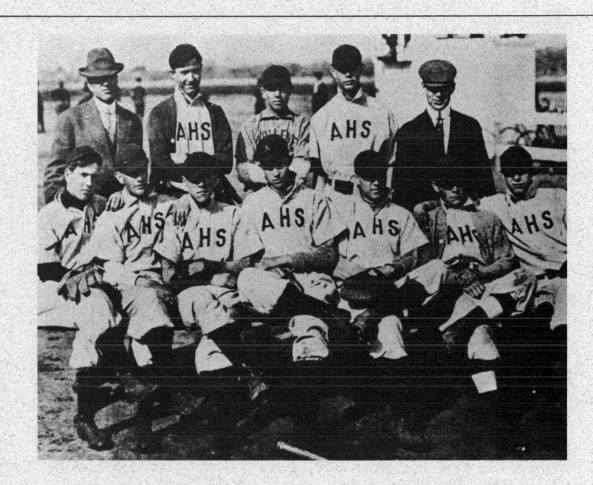

Dwight also played baseball, and here he is pictured (first row center), in 1909, with the Abilene High School team. He was the school's right fielder.

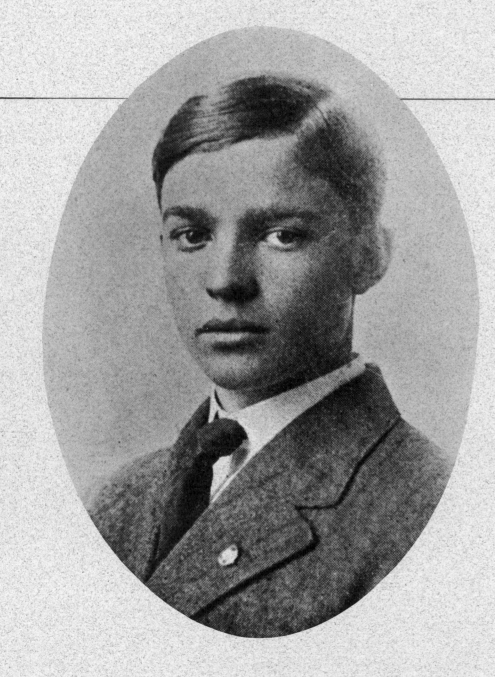

Dwight Eisenhower was graduated from Abilene High School in 1909. This portrait was taken from the Abilene High yearbook.

between lime-ridged hills. Here the natural virgin vegetation, save along tree-crowded creeks and rivers, is a bluestem grass (big and little bluestem) that sometimes grew tall enough to hide a man on horseback along the valley of the Kaw, when the white man first came, and still grows knee- and even hip-high when ungrazed atop the rolling 200- to 400-foot hills by which the Kaw's flood plain is rimmed. Here, especially in the great pastures of the Flint Hills, which run north and south in a twenty-odd-mile strip from Nebraska to Oklahoma and have never been plowed, are vistas every bit as lovely in their way as those of New England. (Under serious consideration for several years, as this is written, has been the creation in the Flint Hills of a Prairie National Park to preserve a portion of this yet-unspoiled beauty against the ugly demands of "progress.") Indeed, the New Englanders who came here in the mid-1850s under the aegis of the New England Emigrant Aid Society as Free Staters to battle pro-slavers for possession of Kansas Territory, and who stamped upon the region a New England culture and conscience, vestiges of which yet remain, waxed ecstatic over the beauty of the countryside in the letters they wrote to their former home and in the numerous books they published. A particularly notable paean of praise to the beauty of this part of Kansas is to be found in Edward Everett Hale's *Kansas and Nebraska,* published in 1854.

Behind Eisenhower, receding into an increasing distance of space and time as the train roared toward his future, lay western Kansas, an area quite different, physically and culturally, from the eastern part of the state. Here are the High Plains, a windswept and virtually treeless land lying almost perfectly flat for hundreds of miles under an enormous sky that becomes increasingly stingy with rain as one approaches the Colorado line. Here the earth's natural virgin cover is a pale-green carpet of buffalo grass, a ground-hugging yet amazingly nutritious vegetation which once fed buffalo by the million, then cattle by the hundred thousand on open range until, alas, most of it was plowed under for the sowing of winter wheat. A hurrying self-absorbed traveler across this land sees literally nothing here. The plain strikes him as totally featureless, a vast monotony, a blank space to which the only possible psychological responses are sleep or an utter boredom shot through with impatience for the trip's end. There are, however, subtle beauties here for one who has sensitively informed perceptions as well as a truly open mind and spirit. "Once you begin to study it, all Nature is equally interesting and equally charged with beauty," asserts Winston Churchill in his eloquent eulogy, based on his own experience, of painting as a pastime.

I was shown a picture by Cézanne of a blank wall of a house, which he had made instinct with the most delicate lights and colours. Now I often amuse myself when I am looking at a wall or flat surface of any kind by trying to distinguish all the different colours and tints that can be discovered upon it, and considering whether these arise from reflections or from natural hue. You would be astonished the first time you tried this to see how many and what beautiful colours there are even in the most commonplace objects, and the more carefully and frequently you look the more variations do you perceive.

Thus it is with the landscape of the High Plains. It is a landscape whose beauties are stark, austere, fugitive, like those of a seascape, its mood and tone determined by the hugely overarching sky which, because of the far distance of a perfectly level horizon, a horizon placed where it is solely by the curvature of the planet, covers four-fifths or so of every scene. And every scene every object—each solitary scrubby tree, each

lonely house, each cloud in the generally cloudless sky—is sharply defined and rendered emotionally significant to a sensitive soul by the vastness of the empty space surrounding it. Moreover, the whole of the scene, like Cézanne's "blank" wall, is "instinct with the most delicate lights and colours."

Some of these austere beauties, and their psychological effect upon the inhabitants of the High Plains, were destined to be captured on canvas by John Steuart Curry who was fourteen in 1911 and absorbing them into his own consciousness when Dwight Eisenhower was leaving for West Point. Curry was raised on a stock farm some scores of miles west of Abilene. And in 1928, with a canvas entitled *Baptism in Kansas,* he would announce a whole new school of Midwestern landscape and genre painting. This canvas depicts an open-air baptismal ceremony ("total immersion" as insisted upon by Baptists) in which an enrapturedly devout young woman in a long white gown, her hands clasped in prayer and her face lifted to heaven, is about to be ducked in a horse tank. The tank, surrounded by a small congregation of weatherbeaten farm folk, stands in a farmyard whose house, barn, and windmill are similar in appearance to those of the Eisenhower homestead, though the contextual landscape is of a country more flat, more arid and treeless than Dickenson County. The sky of glowing clouds and shafted sunlight is a High Plains sky. (Unfortunately, because Curry was afraid that his picture might be taken as a comic, contemptuous comment upon his subject, he painted a couple of flying pigeons onto the sky to suggest the doves in traditional portrayals of Jesus' baptism. The effect was simply to mar the sky and increase the risk Curry ran of mere caricature.) In other canvases, notably one entitled *Sun Dogs,* the artist made the sky itself his subject—its cloud shapes and angled sunlight and the wide sweeps of its many subtly changing colors—achieving thereby some of the effect of an abstract painting, one whose mood is of aching loneliness, of vast brooding solitudes.

By the early 1930s, when Major Dwight Eisenhower, in the office of the assistant secretary of war, was absorbed in the task of developing a plan for total industrial mobilization in case of war (it contained germinal ideas for the "military-industrial complex" against which President Eisenhower later warned us), John Steuart Curry had become joined in the popular mind with Grant Wood of Iowa and Thomas Hart Benton of Missouri as one of a famous triumvirate of regionalists. The work of these three (and that of Wood and Benton especially), would attract Eisenhower much more strongly, naturally, than would the work of those French impressionists and post-impressionists who increasingly intrigued and inspired Winston Churchill. The effect of impressionism upon Churchill's own recreational painting is obviously very strong, whereas this influence is slight if it exists at all in what Eisenhower, with disarming modesty or careless indifference (or both), always called his "daubs." ("Have not Manet and Monet, Cézanne and Matisse, rendered to painting something of the same service which Keats and Shelley gave to poetry after the solemn and ceremonious literary perfections of the eighteenth century?" writes Churchill in *Amid These Storms.* "They have brought back to pictorial art a new draught of *joie de vivre;* and the beauty of their work is instinct with gaiety, and floats in a sparkling air.")

But to return to the young Eisenhower—what he saw with a farewell vision as he looked out of his train window on a June morning in 1911 was a rather nondescript landscape that lacked the interesting scenic variety of the onrushing East and also the interesting spatial immensities of the receding West. A

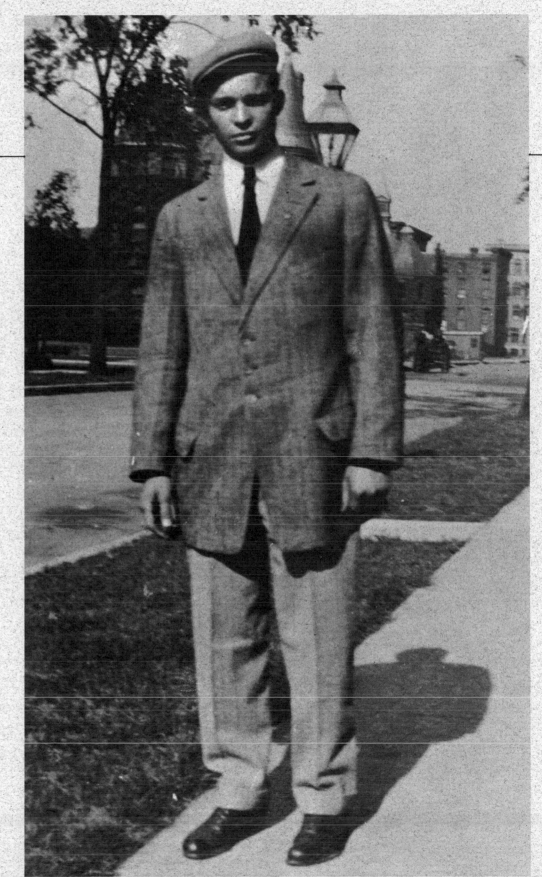

It was young Dwight's own decision to leave Kansas and trade his civilian clothes for cadet grays. This picture shows him in 1911, when he stopped in Chicago on the trip to West Point.

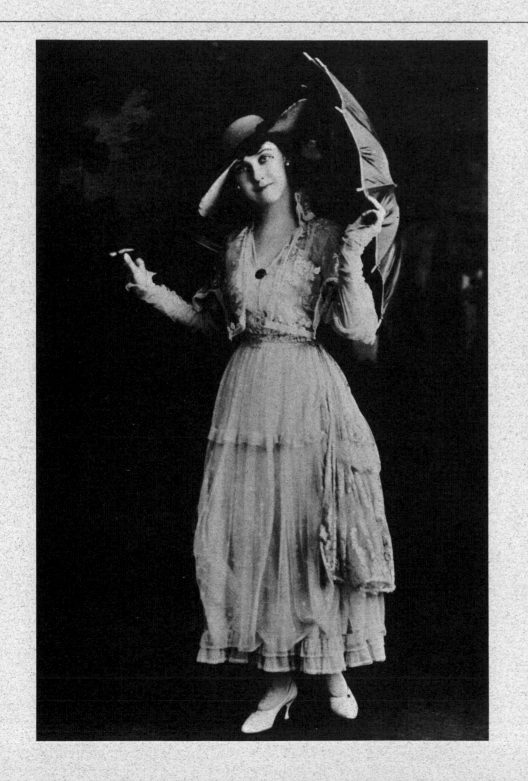

Mamie Doud (Eisenhower) was only eighteen years old in this picture, taken in 1914, two years before her marriage to Dwight. They met when he was a lieutenant in San Antonio, his first military post.

traveler of the most highly trained aesthetic sensibilities passing through this country eastward or westward would be likely to remember or forget it as a kind of meanwhile space, an interval that dully mixed average qualities of both eastern and western Kansas while being itself neither the one nor the other, devoid of uniquely distinctive qualities. Its topography could be described as neither flat nor hilly: it was slightly tilted and gently rolling in a way that limited the horizon while retaining a monotony of foreground, denying to the latter that emotional significance it would have derived from its uninterrupted extension into far distant perspectives. It was neither a treeless land nor one in which trees grew abundantly or to impressive size: small groves of deciduous trees with now and then a group of rusty-looking cedars were visible in every train-passed mile, but the naturally wooded areas were narrowly confined to the banks of streams, and few trees (mostly cottonwoods) grew to any towering size. This was because Dickenson County's weather pattern is of a half-way kind: the average annual rainfall is a little more than half that of Kansas' eastern border and a little more than twice that of the Colorado line; the air flows here at actual wind velocity, not ceaselessly as it virtually does across the High Plains, but much more than it does farther to the east. The natural dominant vegetation of the county's virgin land was neither short grass nor tall exclusively, but an indeterminate mixture of both, and this still prevailed in the pastures across which Dwight Eisenhower had played his cowboy-and-indian games. Carpets of buffalo and stretches of bluestem, these last measuring the wind like sea waves in alternating shades of blue-green and brownish blue, were found in almost equal proportions in Eisenhower's home country.

A nondescript landscape. Yet, one must add, it gave inspiration to an artist who, on that day of Eisenhower's farewell to Kansas, lived some forty miles southwest of Abilene in the little Swedish-American town of Lindsberg, where he headed the department of fine arts in Bethany College. His name was Birger Sandzen. He gained no such national popular fame as Curry's but he had an international reputation and of him cultured Kansans were immensely proud. He came to Kansas from his native Sweden, after studying in Paris, when Eisenhower was four years old, and had ever since been painting the country along the Smoky Hill on large canvases in a style somewhat reminiscent of Van Gogh—so much so that they bore slight representative resemblance to the specific scenes they were said to portray. They had a distinctive lyric quality, however. Empty always of people or animal life, bathed often in the rich light of Kansas sunsets and dawns, they have been described by a Kansas historian as "opalescent jewels of shimmering color." Eisenhower had undoubtedly seen some of them, as a youth, on public display in Abilene or Salina.

The intense emotion awakened by the window-framed moving picture was projected upon the scene by the departing young Eisenhower himself that day. It was spun out of a thousand boyhood memories coupled with a sense of loss and joined, too, with a certain tenseness and apprehension, which even so generally relaxed and self-assured a youth as he must have felt upon taking this plunge out of the familiar into the unknown. It was not an emotion derived from the objective beauties of ripening wheat and ankle-high corn, of timothy and kafir and alfalfa, reaching in wide fields from the tracks to the trees of the Smoky Hill paralleling the tracks a mile or two to the south. His was not an aesthetic experience. It was far too immediately and intensely and solely personal for that.

WEST POINT AND WORLD WAR I

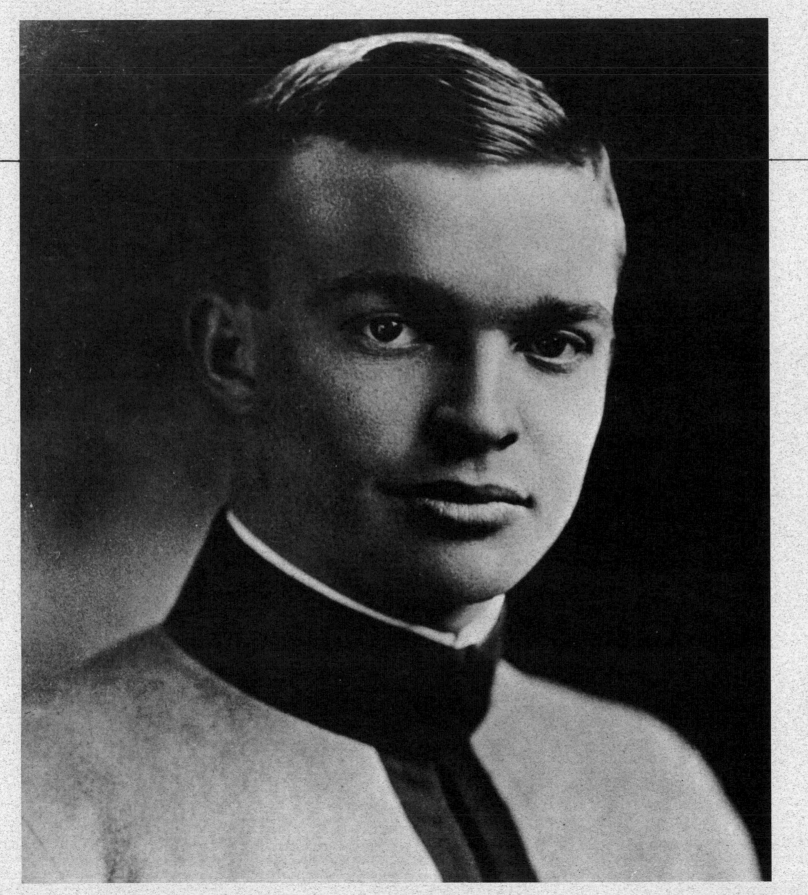

The future toward which he plunged, and which for us is now a famous past to be reviewed in swift retrospect, was for many long years as barren of aesthetic stimuli and activity as his life had been up to June 1911. Its initial years, as a matter of fact, were even more so.

Essentially, the Military Academy was an advanced technical trade school. Its avowed aim was to train soldiers, not educate men. Its curriculum, originally designed by the great Sylvanus Thayer, "Father of the Academy," on the model of the École Polytéchnique in Paris, concentrated upon science and technology—upon mathematics, chemistry, physics, geology, engineering. English was taught solely for the utilitarian purpose of accurately communicating information through the spoken or written word. History was taught for the utilitarian purpose of instilling national patriotism and imparting knowledge about past wars and how they were fought. No serious attention was paid to the humanities. As for the general regimen at West Point, with its ramrod-rigid disciplines and constant military drill, it was considerably *more* hostile to aesthetic development (indeed, to all spontaneity), was more rigorously and exclusively centered upon the "moral" at the actual expense of the "aesthetic" as we have defined these terms, than ever was the regimen of the Eisenhower boyhood home or the educative and cultural influence of Abilene town. The nearest Cadet Eisenhower came to an art course at the Point was mechanical drawing—and that was the one subject he failed of all those he took in his four years, as he often said in deprecation of his natural talents as an artist after he had taken up painting. He also recalled that the only knowledge and skill he was able to bring to painting when he began was that of linear perspective, a knowledge and skill derived from the aforementioned course in mechanical drawing. (Clare Boothe Luce commented

*One of Ike's ambitions was to star on
the Army football team. In the fall
of his second year at the Point, he was
a star halfback. In this picture of the
team line-up, he is second from left.
Omar Bradley is second from right.*

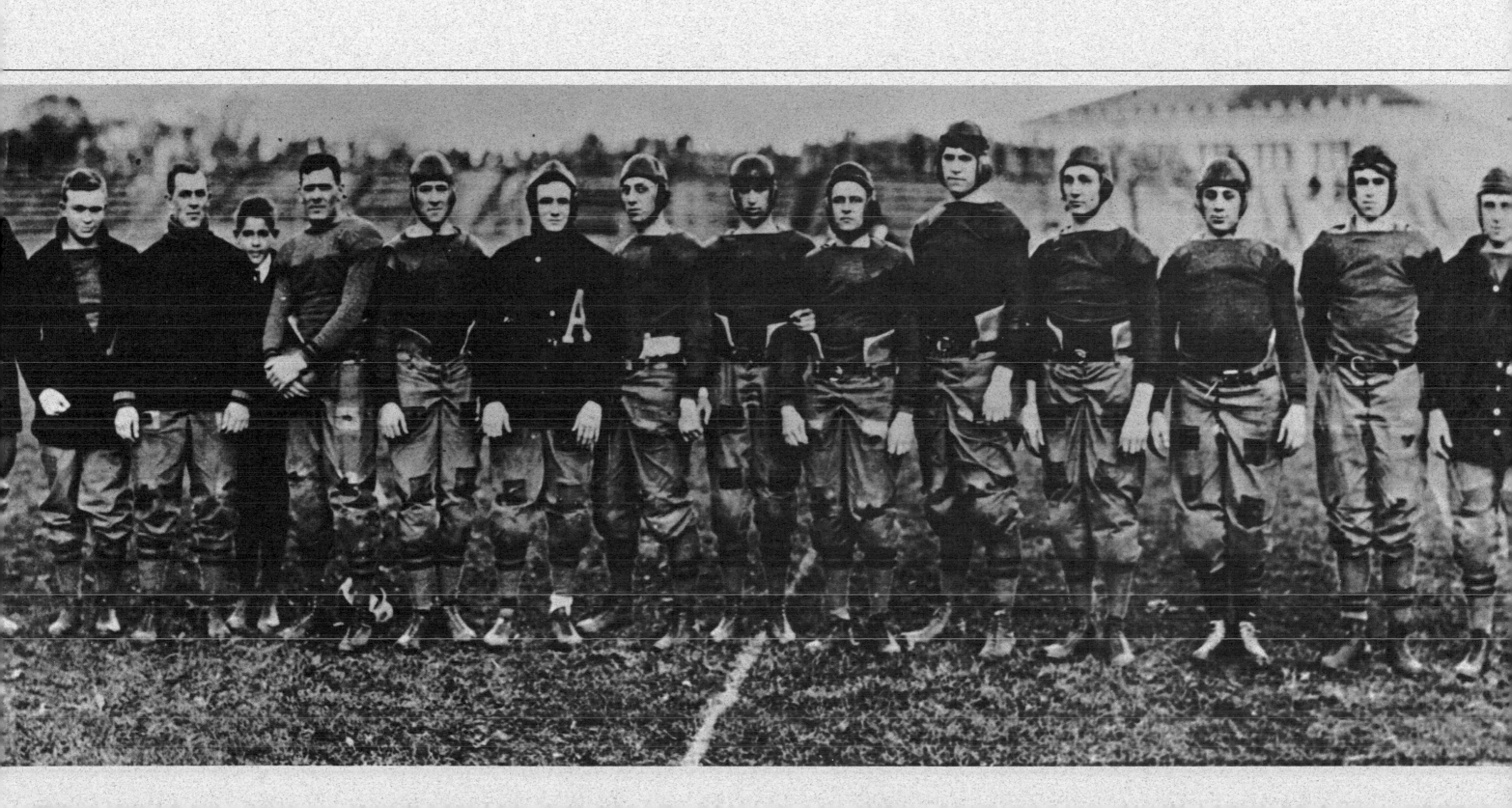

on this in *McCall's* magazine in the mid-1960s. "That he [Eisenhower] may not understand the difference between an aptitude for mechanical drawing and an artist's skill at free-hand drawing explains, perhaps, why he is not in Churchill's class as a painter," she wrote.)

One must add, as he himself was frank to admit, that he took small interest in academic pursuits of any kind during his cadet years. His purely intellectual interests were few. Even if well-taught courses in the liberal arts had been abundantly opened to him he would not, in all probability, have seized upon them in any richly meaningful way at that time of his life. The single strong ambition animating him on his journey across half a continent in June 1911—the dominant purpose by which he was sustained through all the harassing months of his year as a "Beast" (freshman, or fourth-class man) at the mercy of third-class men (sophomores) nearly all of whom were a year or two younger than he—had nothing to do with mental or spiritual growth. His ambition was to become an Army football star. And, in the fall of 1912, when he himself became a yearling (so third-class men were called) and "went out" for halfback, he began to realize this potent dream. At the opening of the football season, barely a month away from his twenty-second birthday, he "weighed something like 174 extremely solid pounds," as he later recalled, which was nearly twenty pounds more than he had weighed when he left Abilene, but "still light for line plunging and line backing." What he lacked in weight, however, he more than made up for in physical toughness and strength and courage, in rugged effort and competitive spirit. He loved the game, was convinced that playing it served a moral purpose, and this conviction remained with him for the rest of his life.

In his book of reminiscences, *At Ease,* published two years before he died, he writes that during World War II, when he was "on the constant lookout for natural leaders," he "noted with real satisfaction how well ex-footballers seemed to have leadership qualifications and it wasn't sentiment that made it seem so—not with names that turned out to be Bradley, Keyes, Patton, Simpson, Van Fleet, Harmon, Hobbs, Jouett, Patch, and Prichard. . . . I think this was more than coincidence. I believe that football, perhaps more than any other sport, tends to instill in men the feeling that victory comes through hard—almost slavish—work, team play, self-confidence, and an enthusiasm that amounts to dedication." Certainly his own enthusiasm amounted to dedication in 1912. He gave to football all that he had of energy and determination, so impressing the varsity coach that he was started as halfback in the very first game of the season after Geoffrey Keyes, the regular halfback, a first-year man (senior) who had been Army's great star the season before, was injured in a pregame practice session. He promptly justified the coach's confidence in him. To Army's 27–0 victory that day (the opponent was small Stevens) Eisenhower contributed mightily, as he did also a week later to the defeat of Rutgers, 19–0; and he continued to perform impressively whenever he was substituted for Keyes after the latter, recovering from his injury, returned to his starting position. Newspapers touted Eisenhower as "one of the most promising backs in Eastern football," a future All-American.

Then came catastrophe.

He suffered a painfully twisted knee in a game with Carlisle (that was the year in which the legendary Jim Thorpe *was* Carlisle) on November 9. He was sufficiently recovered to play the following week against Tufts. But this was the last football game in which he ever played. While carrying the ball in a line plunge he was tackled in a way that severely wrenched the knee

(Continued on page 97)

64

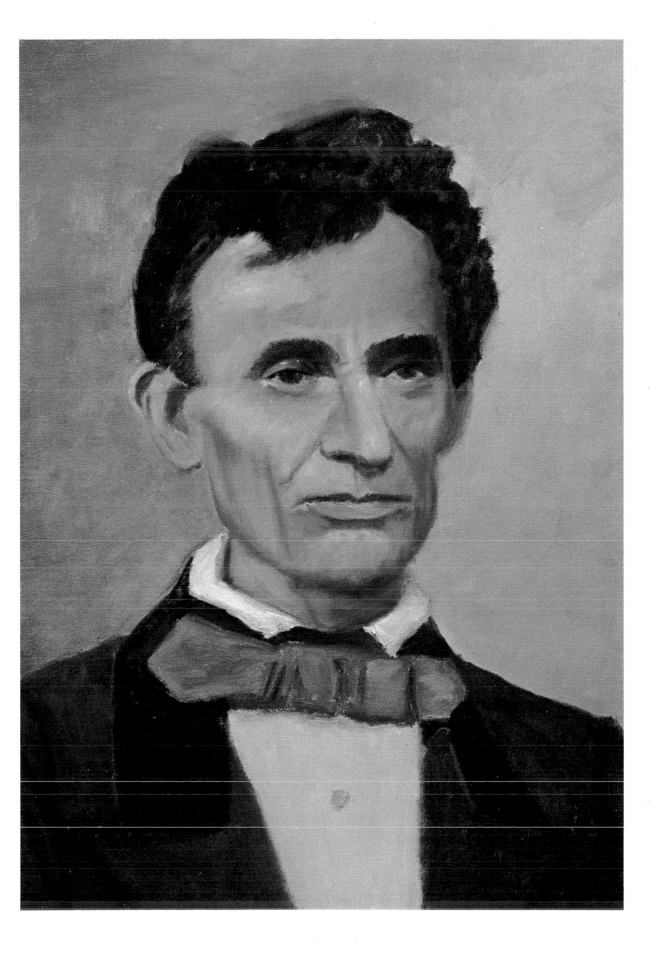

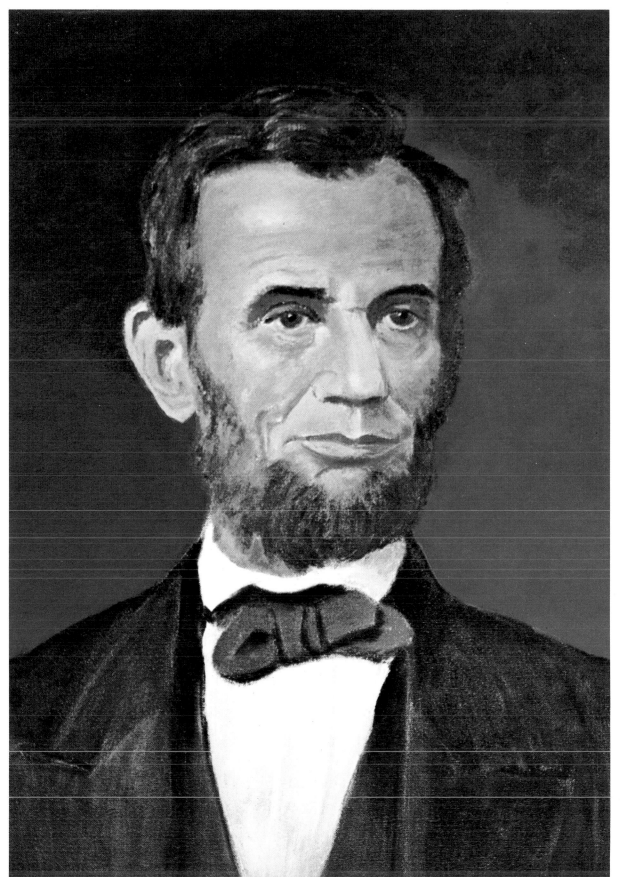

PLATE 17

MELANCHOLY LINCOLN

From the Eisenhower College Collection, Seneca Falls, New York. Sadness pervades the canvas. It is interesting to note that the clean-shaven Lincoln has been placed in the same position as the bearded subject, right. 16 x 12 inches.

PLATE 18

PORTRAIT OF LINCOLN

From the collection of The National Archives, Washington, D. C. Eisenhower greatly admired Lincoln and painted several portraits of him. This one, probably completed in 1953, was reproduced and given to the White House staff and friends, Christmas, 1953. With careful highlighting, he achieved excellent modeling of the face. 30 x 25 inches.

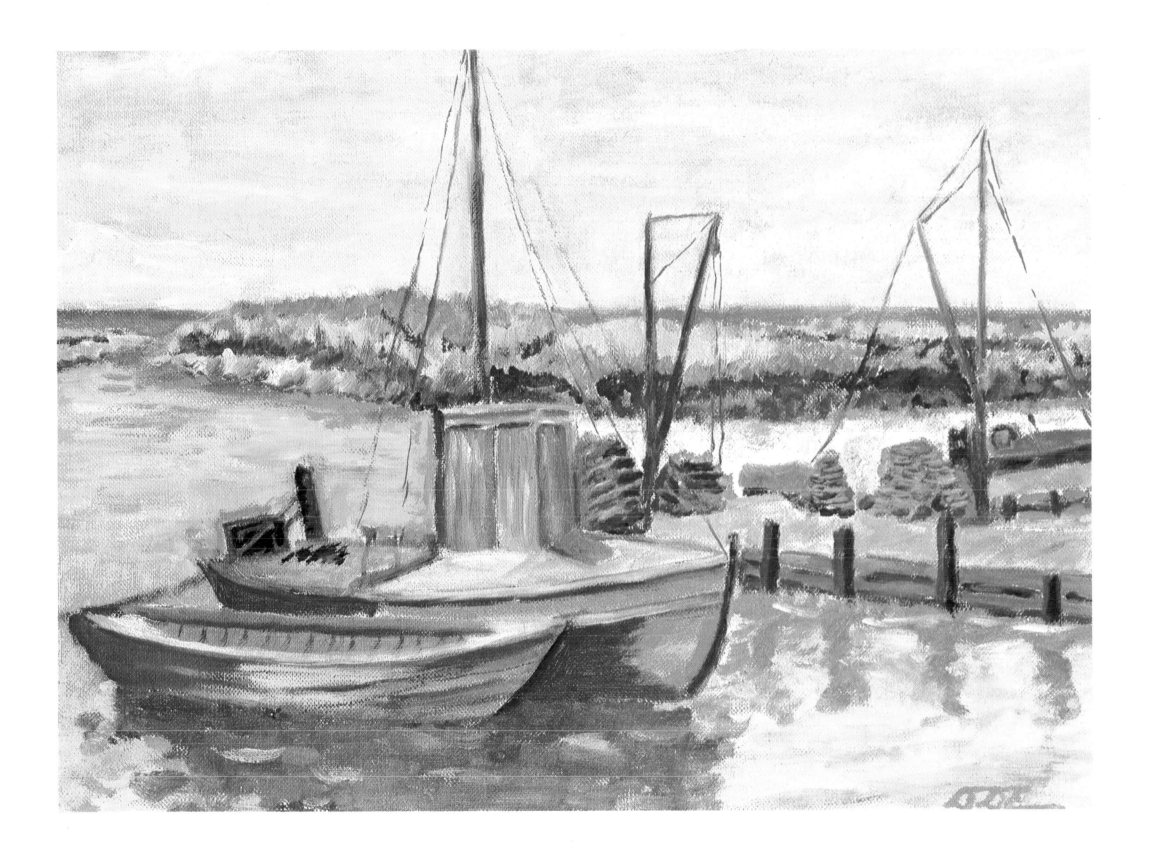

PLATE 19

TWO FISHING BOATS AT DOCK

From the collection of Mrs. Harold Hill Titus. An intensified blue for the water at the horizon line accomplishes a feeling of distance. Swatches of color on the boat in the near foreground demonstrate a swiftness of paint application not often recognizable in Eisenhower's work. A loose rendering of the mast ropes plays an important part in tying the composition together. 12 x 16 inches.

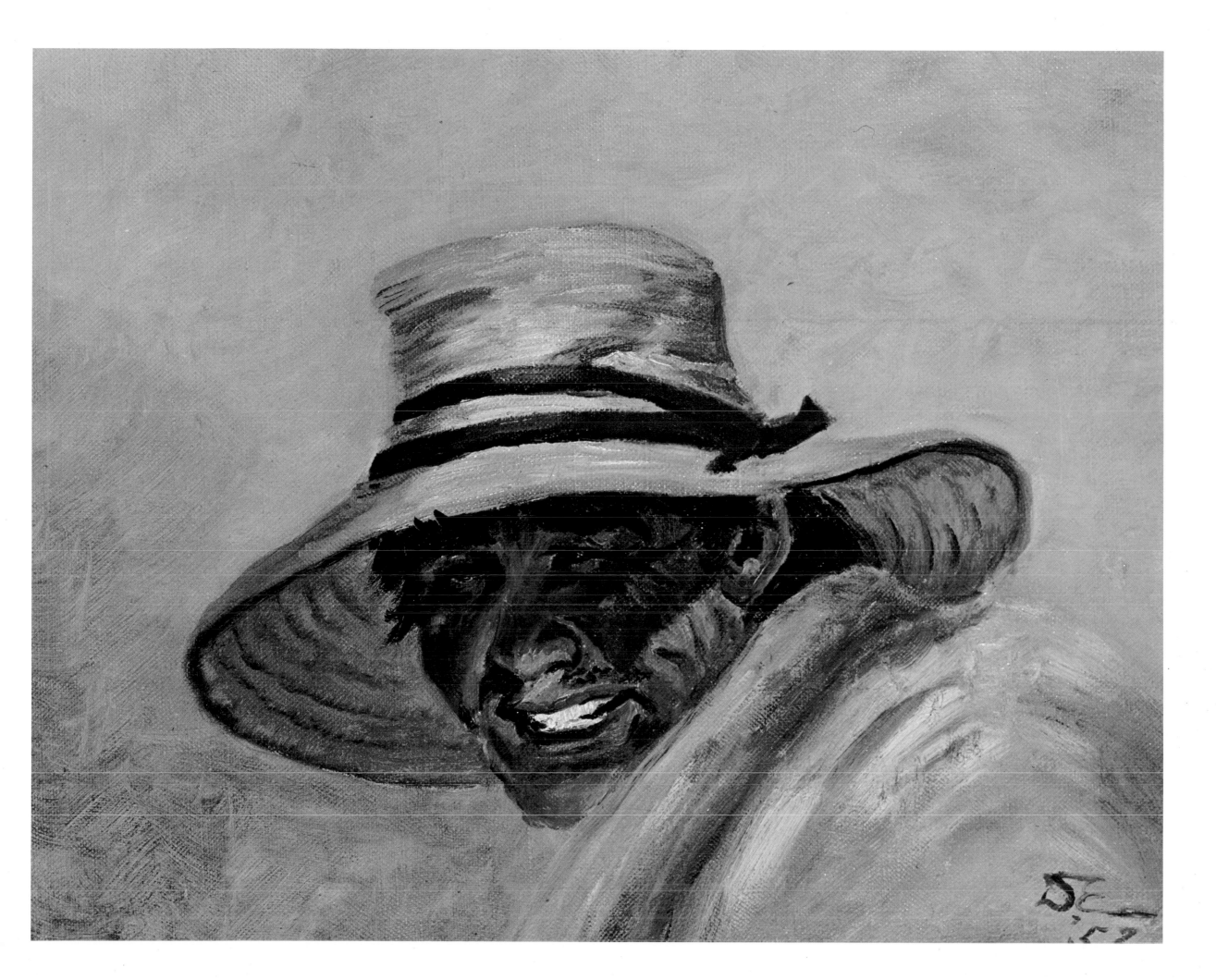

PLATE 20

MEXICAN

From the collection of Mrs.
Mamie Doud Eisenhower,
Gettysburg, Pennsylvania.
Taken from an advertisement
in 1953, this is one of Mrs.
Eisenhower's favorite paintings.
When it was completed she asked
her husband to save it for her.
12 x 16 inches.

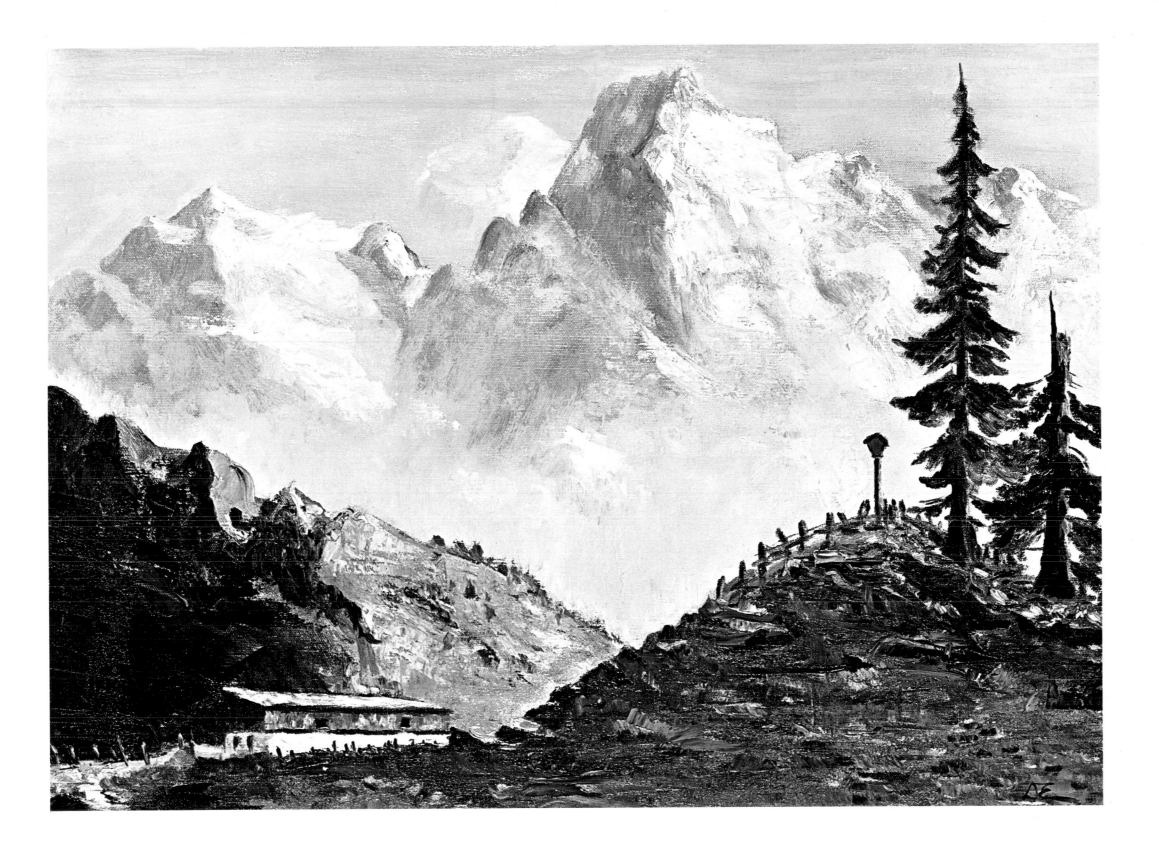

PLATE 21

AUSTRIAN MOUNTAIN SCENE

From the collection of
Mrs. Frances Doud Moore,
Belaire Beach, Florida.
The loftiness of snow-covered
Austrian Alps in the background
and the warmth of earth colors
in the countryside below give
the painting a majesty typical
of the locale. Eisenhower
painted the picture for Mrs.
Moore and inscribed on the
reverse of the canvas,
"D.D.E. to F.D.M."
18 x 24 inches.

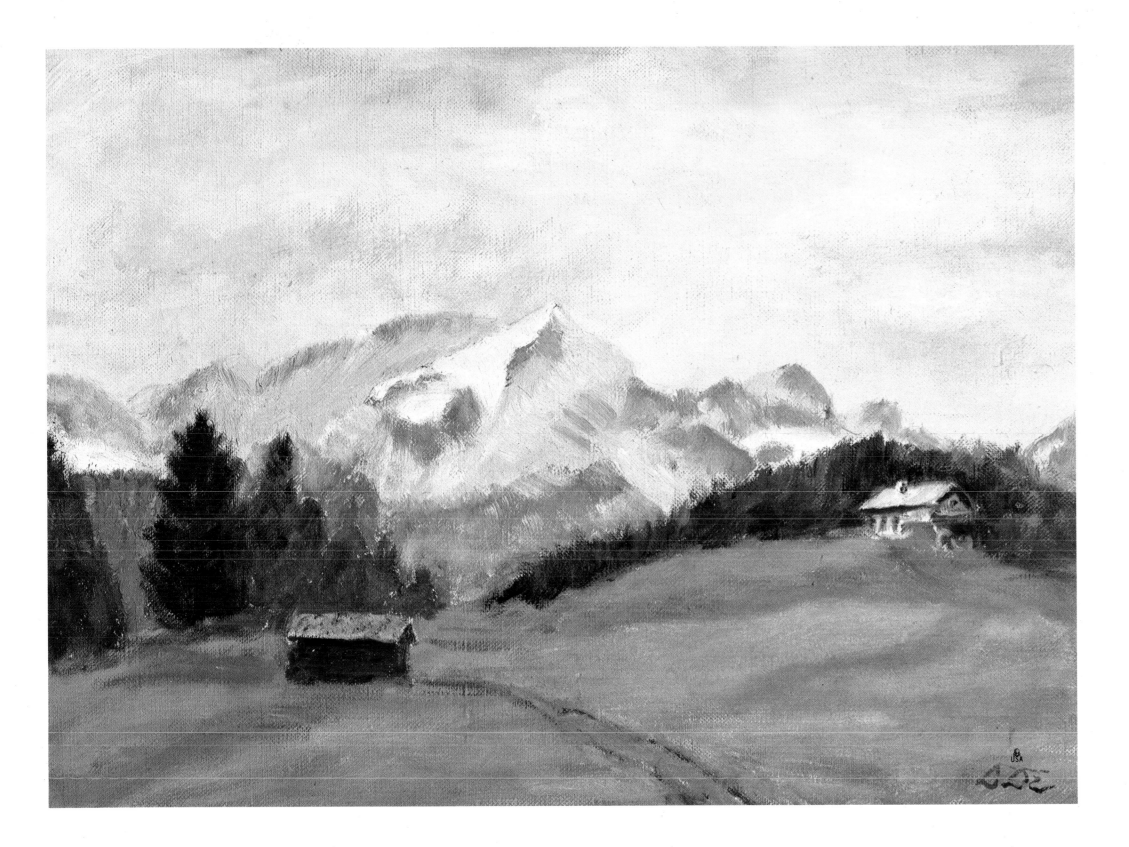

PLATE 26

HOUSE ON THE HILL

From the collection of
Mr. Sigurd S. Larmon.
Like Plate 21, this
is also reminiscent of
Eisenhower's paintings of the
European Alps and was probably
executed about the same time.
Rendering of the mountains is
not dissimilar to those in
On The Reverse Side (Plate 37),
but his treatment of the
foreground is quite different.
12 x 16 inches.

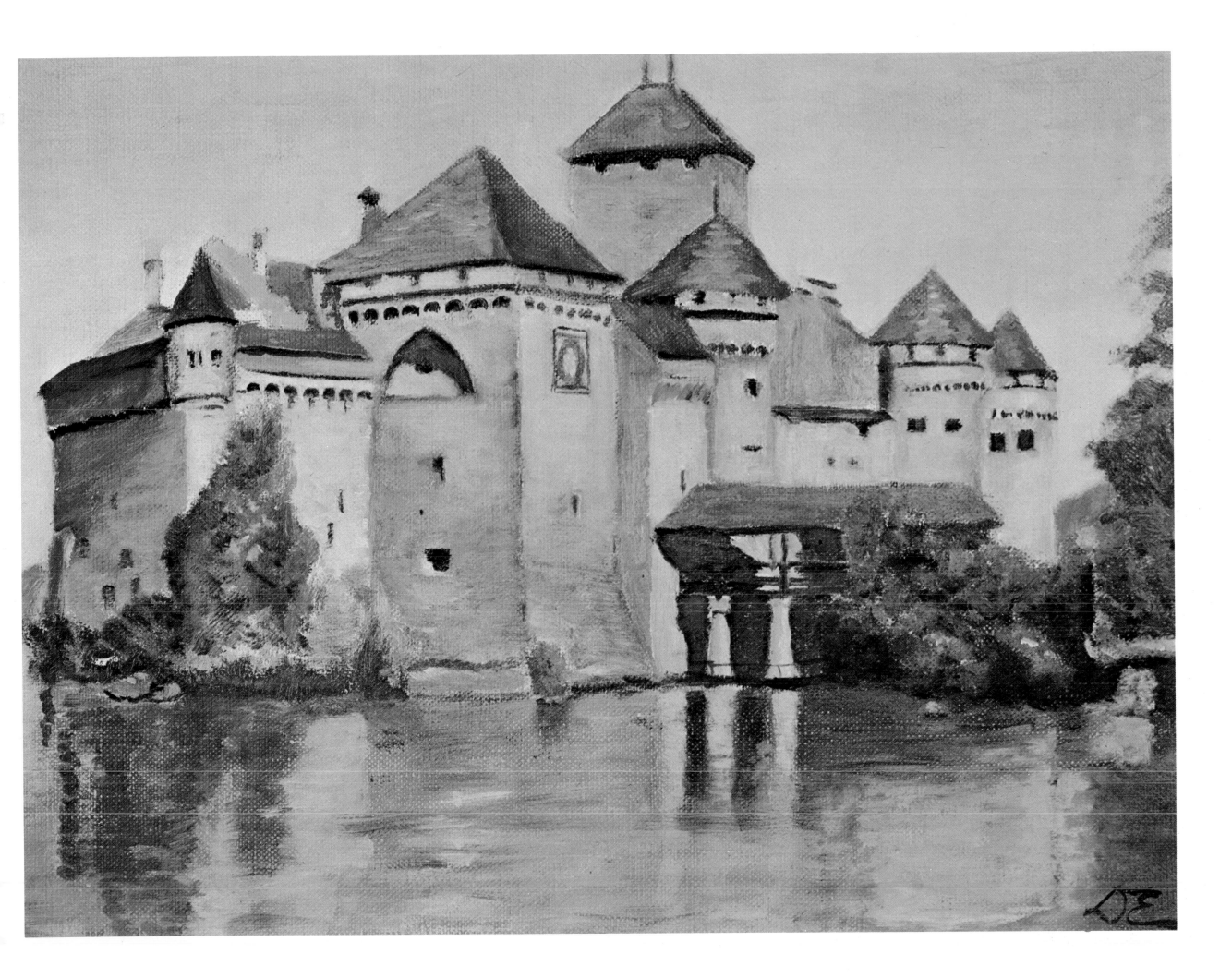

PLATE 27

CASTLE OF CHILLON

From the collection of The Honorable and Mrs. Gabriel Hauge, New York, New York. Reflections in water seem to have fascinated Eisenhower. In this 1955 painting he has achieved notable success with technique. His early course in mechanical drawing at the Academy, to which he attributed his daring in attempting perspective drawing, has been brought into use here in the turrets and other architectural forms of the castle.
10½ x 13½ inches.

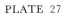

PLATE 28

A FRENCH GARDEN

From the collection of Miss
Susan Elaine Eisenhower.
Again, we have a multiplicity
of techniques and a lavish
use of color, with incredibly
thick impasto on a diminutive
canvas. Splashes of various
colors create an illusion of
floral profusion. An arboreal
arrangement, creating a vista
beyond, leads the attention
back to the center foreground
by a clever direction of
tree limbs and the use
of bright yellows.
4 x 6 inches.

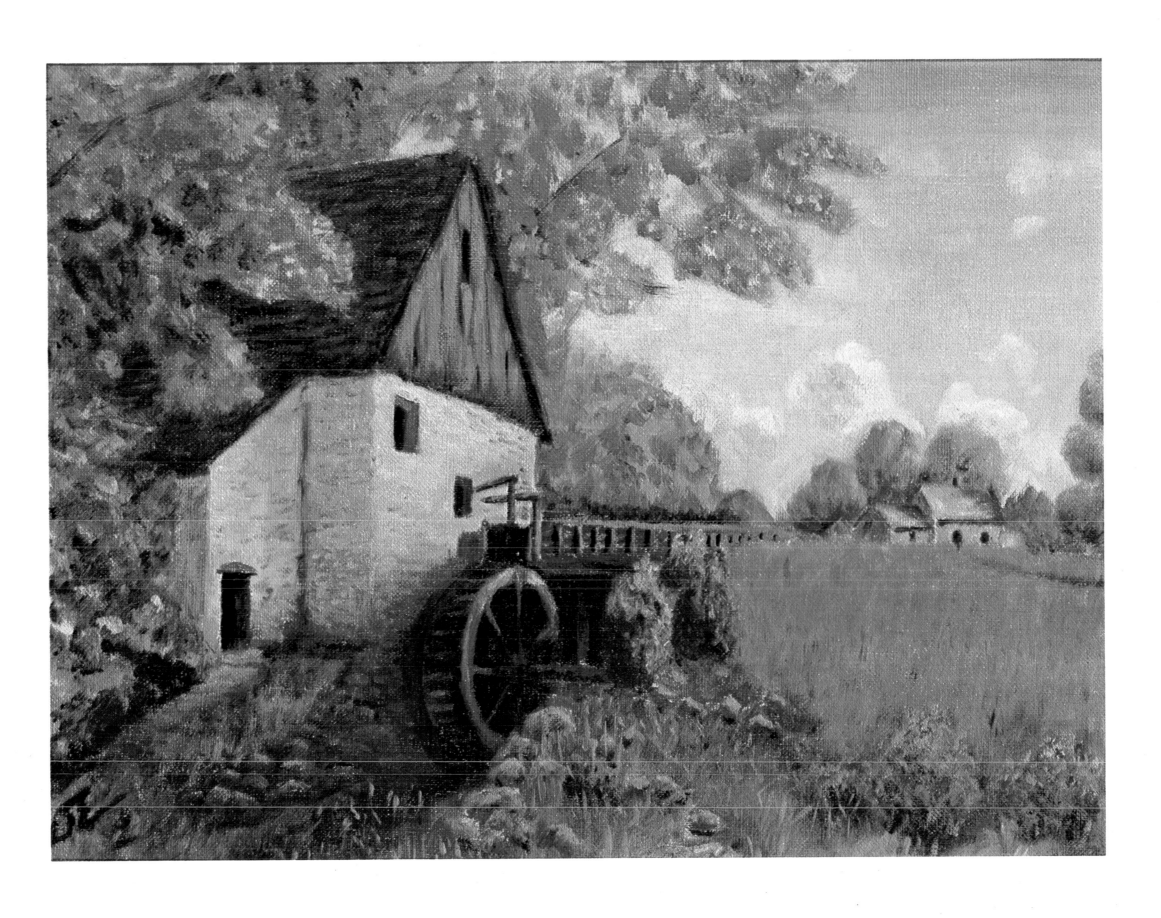

PLATE 29

OLD MILL

From the collection of
General Robert Cutler,
retired, Boston, Massachusetts.
This mill, a favorite subject
of Eisenhower's, was painted
in early 1955. It was presented
to General Cutler by President
Eisenhower on March 12, 1955,
at a White House dinner in
honor of Cutler when he
returned from a trip as the
President's Special Assistant
for National Affairs.
15 x 18 inches.

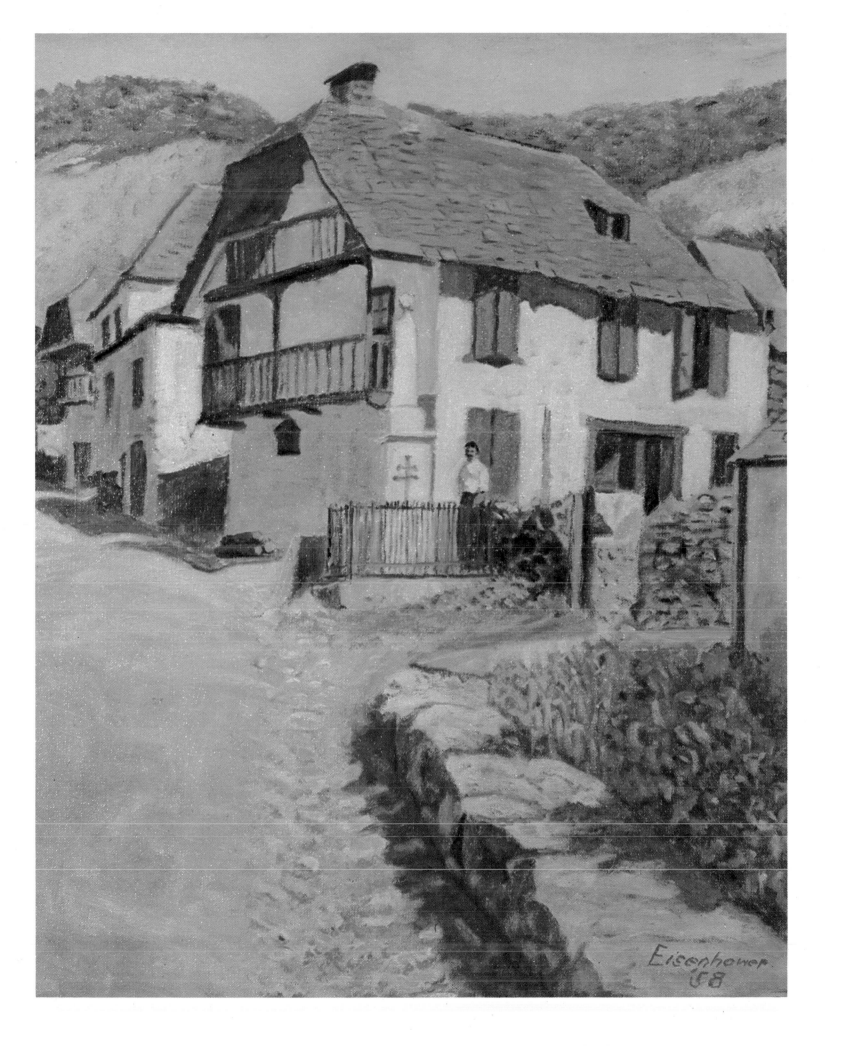

Eisenhower
'58

PLATE 32

WHITE HOUSE WITH BROWN SHUTTERS

From the collection of Mr. Arthur Hays Sulzberger of New York, New York. Eisenhower presented this rather unique street scene to Mr. Sulzberger in 1958. It no doubt depicts a place familiar to both of them. The painting almost resembles a pastel or watercolor. Using a minimum of colors, Eisenhower created a unique composition by emphasizing geometrical shapes and overlapping planes, contrasting dark and light and cool greens and warm browns. The painting evokes a feeling of coolness and quiet—a desertedness—save for the lone figure of a man near the house.
20 x 16 inches.

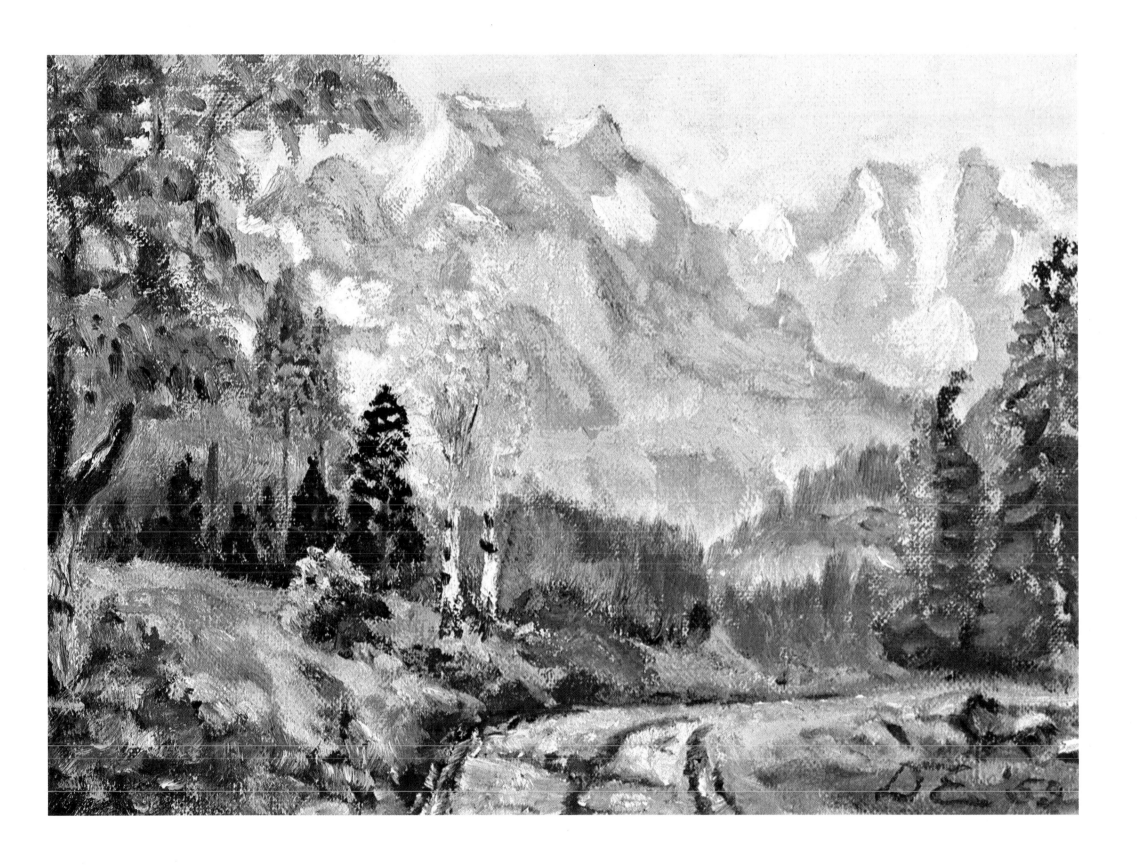

PLATE 33

MOUNTAIN FALL SCENE

From the collection of Admiral and Mrs. Lewis E. Strauss, Washington, D.C. Fall colors were the dominating factors of many of Eisenhower's paintings. His preoccupation with color, and fascination with it, characterizes most of his work. Although color first catches the viewer's eye here, closer observations will reveal a rather masterful handling of the mountains for a painter who chose not to call himself an artist.
12 x 13⅞ inches.

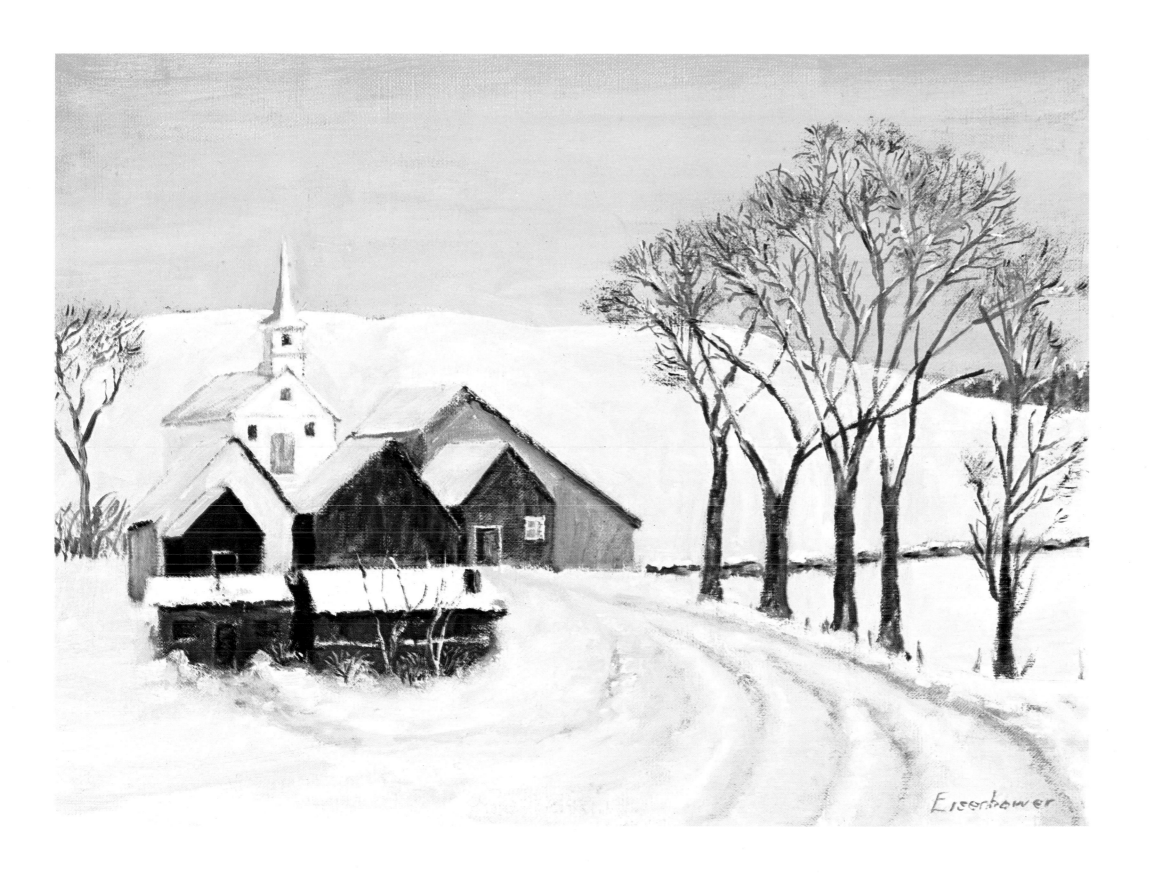

PLATE 34

WHITE CHURCH IN THE COUNTRY

From the collection of
President and Mrs. Richard M.
Nixon, Washington, D.C.
Painted in 100-degree weather in
Palm Springs, California, in
1962, President and Mrs. Nixon
received this painting from
General Eisenhower the same
year. It hangs in the family
quarters of the White House.
In referring to it in 1972
Mrs. Nixon said, ". . . warm and
human aspects are reflected in
his paintings—his love of
nature, his quiet but firmly
rooted religious beliefs, and
his response to the beauty
and mystery of life."
14 x 18 inches.

he had twisted the week before. He had to be half-carried from the field, was hospitalized for several days until the swelling went down, and then foolishly (he says he had no warning from the doctors against undue strain) engaged in routine riding drill. He leaped from a horse, landed with his full weight upon his bent injured knee, and thereby tore cartilages and tendons so seriously that doctors feared at first that he would have to be discharged from the Corps as permanently crippled. And, indeed, from this injury he never fully recovered. "To this day I have to be careful in my movements," he said in 1967. "Periodically in the past half-century I have had to spend time in the hospital to recover from careless straining of that injured knee."

The psychological effect was devastating for a time. "I was almost despondent and several times had to be prevented from resigning by the persuasive efforts of classmates. Life seemed to have little meaning; a need to excel was almost gone." And instead of paying more attention to his studies he paid less; instead of becoming more respectful of the Point's rigid rules of conduct he became more careless of them. At the end of his plebe year his total academic standing had been fifty-seventh in a class of 212 (he stood tenth, however, in English) and the "skin sheets" (records of "delinquencies") showed that he collected only somewhat more than the average number of demerits for such offenses as "late to target formation; absent at 8 a.m. drill formation; shelves of clothespress dusty; in room in improper uniform 1:50 p.m.; dirty washbasin at retreat inspection," etc. For each of these he walked "punishment tours" for a prescribed period of time, stiffly marching, eyes straight ahead, his rifle at a precisely prescribed angle over his shoulder. At the end of his third-class year his standing had slipped to 81st in a class that had shrunk to 177, and the number of his demerits had increased. Nor did his conduct improve there-

after. In his final year on the Point he stood 125th in discipline out of a graduating class of 164. His graduation order was 61. Obviously these records were no measure of his native abilities. He had no desire to be an outstanding or even a "good" cadet. He impressed his instructors at graduation time as (in the later words of one of them) "a not uncommon type, a man who would thoroughly enjoy army life, giving both to duty and recreation their fair values" but not "a man who would throw himself into his job so completely that nothing else would matter." He simply didn't care very much.

And this attitude carried over into the years that followed.

Seldom did he perceive an object worthy of pursuit with "an enthusiasm that amounts to dedication." When he did so he pursued it with the same boldness, self-assurance, and tenacity that had characterized his decision, and the implementation of his decision, to try for a service academy appointment despite the hurt (which he deeply regretted) that must come to his parents from his flouting their pacifistic commitments; and that had characterized his determination to star at West Point in sports.

One such object presented itself to him not long after he reported at Fort Sam Houston in San Antonio, Texas, to begin his first tour of military duty after leaving the Academy. He met there a slender slip of a girl who, in appearance, resembled the actress Lillian Gish, who had just won her first fame in D. W. Griffith's motion picture *The Birth of a Nation*. Her name was Mamie Geneva Doud. He pursued her with single-minded intensity, refused to be intimidated by the multiplicity and "superior social standing" of her other beaux or by her initial attempts to rebuff him, and was married to her in her hometown, Denver, Colorado, on July 1, 1916.

Less than a year later came America's entrance into the First

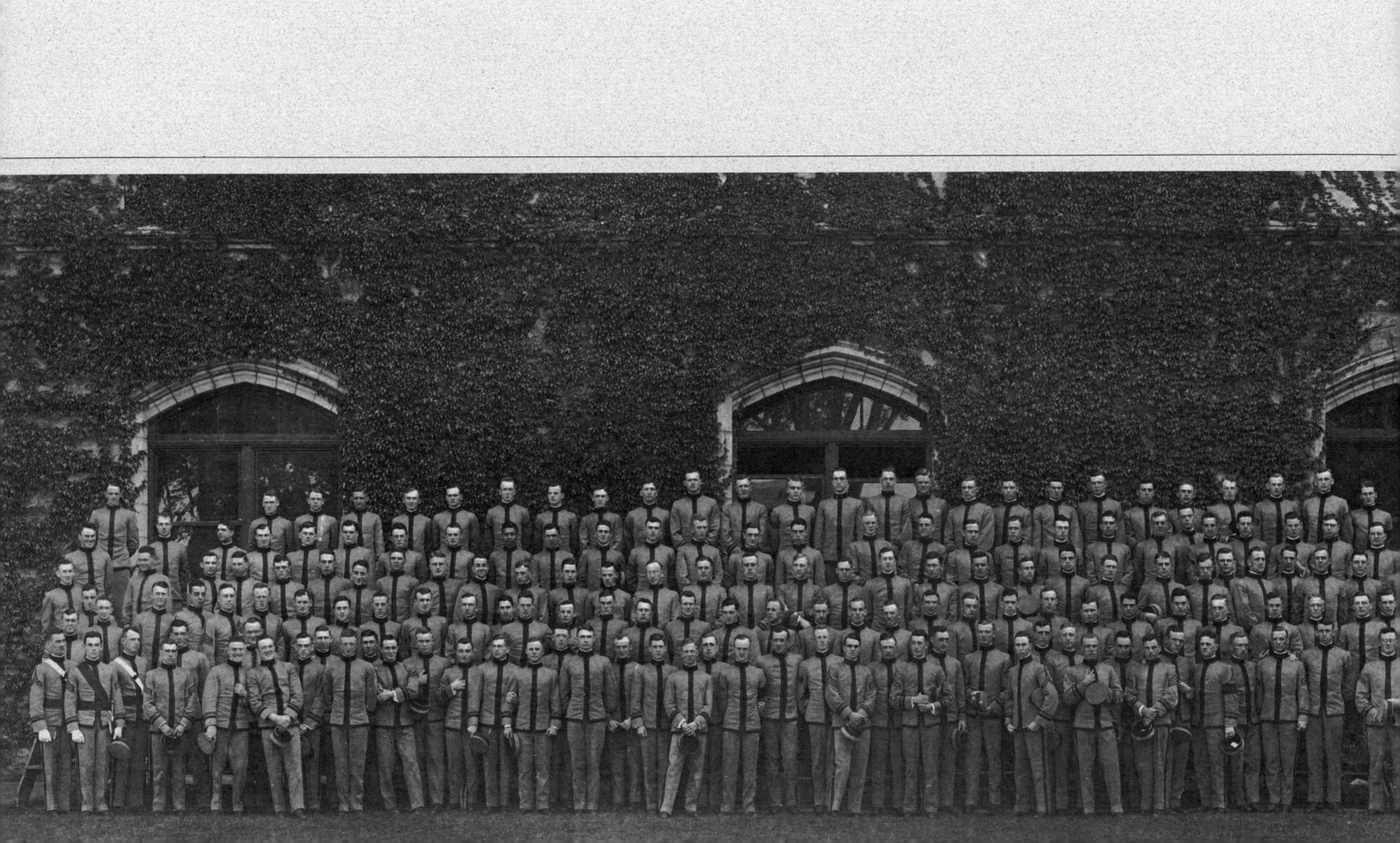

World War. His overriding objective then became overseas combat service at the earliest possible date. This, he thought, was the indispensable condition of any great or even satisfactory military career for him during the years ahead, especially since he was two or three years older than the average of his West Point class and by that token started two or three years behind them in the race toward high promotion. He therefore threw himself wholeheartedly and -mindedly into his assigned tasks. He believed that their successful performance would lead to the overseas duty for which he yearned. He was mistaken. Sent as an instructor to an army training school he proved to be so effective at training men that he was kept in his training role month after month, going from one post to another, before being assigned finally to command a new tank training center at Camp Colt in Gettysburg, Pennsylvania. (At Fort Leavenworth, when tank outfits were still a part of the Army Engineers, he had gone through a pioneer "tank school"; he had become convinced of the importance of tanks for the future.) The job was a challenging one—in some ways as difficult and challenging as any he later tackled—and he made an outstanding success of it. Ten years later he was awarded a Distinguished Service Medal whose citation said: "While Commanding Officer of the Tank Corps Training Center he [Eisenhower] displayed unusual zeal, foresight, and marked administrative ability in the organization, training, and preparation for overseas service of technical troops of the Tank Corps." But he was still at Camp Colt, with the rank of lieutenant colonel (temporary) and some 6,000 men under his command, when the war ended.

Dwight Eisenhower was graduated from West Point in 1915. Of 164 graduates, 59 officers attained the rank of general, and two, Eisenhower and Bradley, became five-star generals. Right is Ike's graduation portrait, where he is pictured in full-dress uniform. Opposite is the illustrious graduating class. Eisenhower is tenth from the left in the front row.

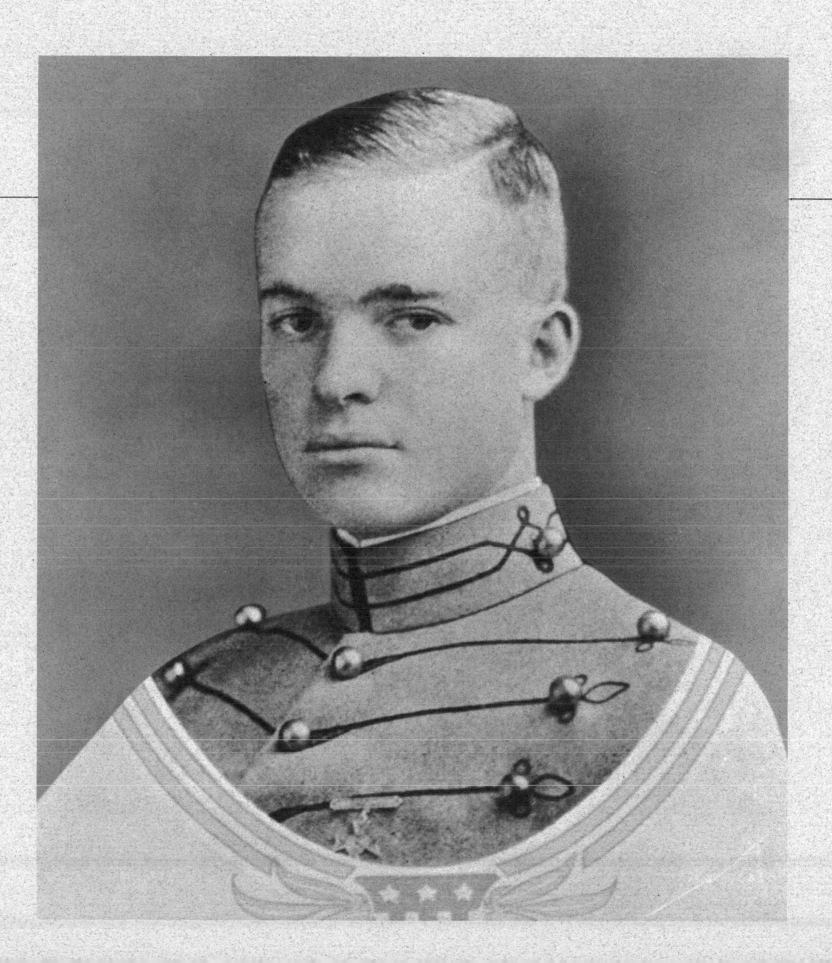

BETWEEN TWO WARS

He then faced a future that seemed to him more blank, stultifyingly so, than any he had faced before. It appeared utterly devoid of meaningful goals toward which he could orient himself career-wise and in terms of which he might measure progress or success. He reverted in early 1920 to his 1917 rank of captain (permanent), was then promptly promoted to major (permanent). He would have been further reduced in spirits, though not at all surprised, to learn that he would (as he did) remain a major after fifteen years had passed.

"Never again!" was the average American's response to the betrayal at Versailles of Wilsonian idealism, a betrayal to which Wilson himself contributed, rendering null and void the immense sacrifice—ten million slain in battle, twenty million permanently maimed, a civilization destroyed—that had been laid upon the bloody altar of war. Isolationist sentiment rose and swept like a tide across the land, overwhelming the enfeebled Wilson's effort to obtain Senate ratification of the Versailles Treaty with its incorporated Covenant of the League of Nations. And not only did the people thus seek to divorce themselves from foreign affairs, they also turned away from domestic affairs, from public affairs in general. These last became, by default, the private affairs of big businessmen who proceeded for a decade, unhindered, to pile up vast monetary profits for themselves and vast future troubles for America and the world. In this postwar America there was little of prestige and virtually nothing of glory for a professional officer in an army shrunk to little more than a token force by lack of funding. Indeed, uniforms were soon so frowned upon by the great mass of civilians that officers on staff duty in Washington were ordered not to wear them as they went about their ordinary office duties. Nor was there the slightest prospect of military glory for such as Eisenhower in the foreseeable future.

He began to consider, sometimes quite seriously, the possibility of resigning his commission. His eldest brother, Arthur, was now a high-salaried executive in the Commerce Trust Company of Kansas City, one of the largest banks in the Midwest; Edgar, after graduation from the University of Michigan Law School in 1914, had gone to Tacoma, Washington, where he was now well started upon his road to wealth as a corporation lawyer; younger brother Roy was prospering as a druggist and civic leader in Junction City, Kansas; still younger brother Earl was reportedly doing well at the University of Washington, where he majored in electrical engineering; and Milton, the youngest Eisenhower, was doing brilliantly at Kansas State after which he would go to Washington, D.C., to become, at an unprecedentedly young age, one of the very top administrators in the U. S. Department of Agriculture. Why should he, Dwight, remain trapped within the uniform, the repetitive irrevocable routines of army life with no promise of really substantial reward, when his brothers were doing individual things, free and exciting things, and earning more and more money and prestige by doing so? Why should not he himself enter the competitive business world and make a lot of money? Perhaps he would have done so had a suitable opportunity presented itself to him in the early 1920s. None did. So he stayed on in the army, was stationed successively at Camp Dix, at Fort Benning, and then at Camp Meade, Maryland, where he graduated from the Tank School and met a man who profoundly influenced him personally, and influenced, also, his career.

This man was Brigadier General Fox Conner whose intellectual vitality would have been remarkable in any profession; it came close to being unique among the older professional officers of the U. S. Army during the 1920s. Conner read aright

the signs of the times. He was convinced in the immediate aftermath of the First World War that this war had been historically inconclusive, that another world war would occur within twenty years, and he was on the lookout for young officers who, if properly motivated and trained, would be ready to serve in top command posts when the crisis came. He had already decided upon one such man, Major George Catlett Marshall, who, as a colonel (temporary), had been G-3 (in charge of operations) of the First Army in France and in that capacity had fashioned what Pershing himself had praised as a "masterpiece of logistics." It was Marshall who had planned and managed the transfer of a half-million men and some 2,700 guns from the Saint-Mihiel sector to the Argonne in barely two weeks with such secrecy that the Germans were unaware of the transfer until the great Argonne offensive opened in late September 1918. And Conner, almost at his first meeting with Eisenhower, saw in Major Eisenhower a man fit to become Marshall's teammate at the highest level in the war to come.

He said so frequently and emphatically in the following months and years, after he had, through channels, summoned Eisenhower to Camp Gaillard in the Panama Canal Zone as executive officer of the 20th Infantry Brigade, which Conner commanded. He talked a lot to Eisenhower about Marshall. His highest praise, Eisenhower soon learned, was to say, "You handled that just as Marshall would have done." He strove to inspire in the younger man a new dedication. "Great tasks lie ahead for you!" he said over and over again. "You must prepare yourself for them. Take advantage of every opportunity to learn and grow. Study hard! Work hard!"

And Eisenhower listened, dubiously at first, then with more and more belief.

Thereafter his professional life had some meaning again. He said to Mamie and his brothers and to his most intimate friends, all through these years, that his highest ambition was to "make colonel"—that is, be promoted to full "chicken" colonel—and he very much doubted he could do so, in view of his two-year handicap, before he retired. He refused to become tensely ambitious. He continued to employ what the present author, referring to young Eisenhower's last years in Abilene, once described as "controlled drift" or "the strategy of the relaxed will." Only with a good deal of tentativeness did he accept the judgment of himself and his high "destiny," which Conner sought to impress upon him; and his wait-and-see attitude militated against excessive egotism. But he did now have a design upon the future, if a very loose and general one, in terms of which his "strategy of the relaxed will" would be organized and directed. He was goal-oriented to a degree sufficient, at least, to inspire and direct a certain amount of extra effort. If Fox Conner's assessment of his abilities was accurate, he, Dwight Eisenhower, was obliged to develop them toward a maximum effectiveness. If Fox Conner's forecast of future war proved to be accurate, he, Dwight Eisenhower, would be ready for the war when it came.

He returned to the United States from Panama in September 1924. The next step for him, Conner insisted, was to go through the Command and General Staff School at Fort Leavenworth, Kansas: it was almost exclusively from among the graduates of the school that future general officers would be chosen—and he knew that Conner was "pulling strings" to get him appointed to Leavenworth. He therefore studied hard in preparation for this possible if not probable event during two otherwise exceptionally easy tours of duty—first as recreation officer (football was again, briefly, among his active concerns) for the Third Corps Area in Baltimore, Maryland, then

as recruiting officer at Fort Logan, Colorado. In midsummer, 1925, he received a cryptic wire from Fox Conner admonishing him to "make no move," to "be ready." A few days later his orders came.

He reported to Leavenworth on August 19.

And from the Command and General Staff School, a little more than nine months later, he graduated first in a class of 275 of the most able and ambitious men in the army!

It was a feat of which he was justifiably proud forever after and which could not but have astonished those West Point instructors who remembered him as he had been during his last two years at the Academy. The Leavenworth School was notorious for its "toughness." Many a student broke under the strain it imposed. Some in the past, if not during the 1924–25 term, had suffered total nervous collapse, and at least one had been driven to suicide. A year or so after Eisenhower's graduation, the system of graduation order numbers was abolished at the school because the intense competition it imposed ruined so many fine officers. Eisenhower emerged from the prolonged ordeal unwontedly pale and worn (never had he worked so hard in all his hard-working life before) but more deeply, serenely confident of himself, of his ability to stand up under any pressure and handle competently any job that was required of him, than he had ever been.

He knew that from now on his name would be placed high on the General Staff Corps' Eligible List, and from now on he very consciously chose assignments, when choice was possible, that would advance him toward high command. He saw opportunity, for instance, in a detached assignment which most officers would (and did) shun, that of preparing for the American Battle Monuments Commission a guidebook that tourists to the French battlefields, on which Americans

In 1926 when Dwight was stationed in Washington, D.C., he took time off for his yearly trip to Abilene to attend a family reunion.

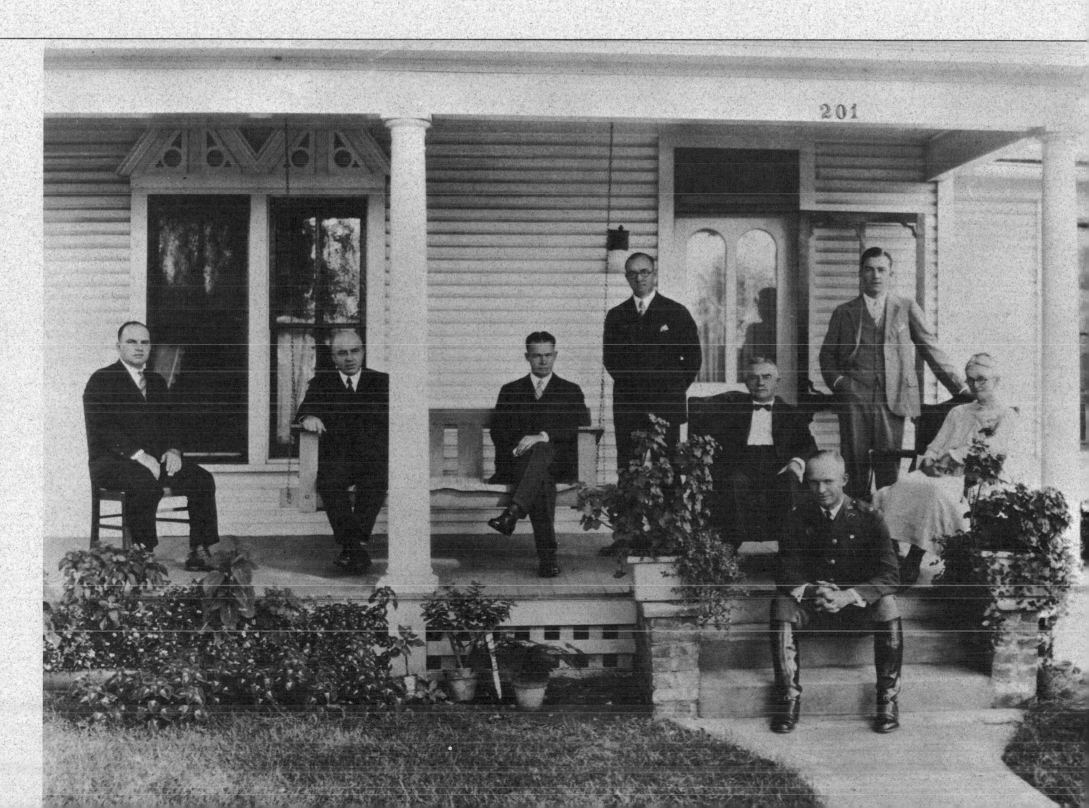

had fought during World War I, might use. It was a difficult task (he was greatly aided by the trained writing talent of his brother Milton), but he learned from it an immense amount about the strategy, tactics and logistics of the AEF. Its end-product was a guidebook on historical principles that remains one of the best reference works for students of American military activity overseas in 1917–18; and the work was done under the appraising eye of the top commander of that activity, for General John J. Pershing was chairman of the Monuments Commission. "I wish . . . to express my appreciation of the splendid service which he [Major Eisenhower] has rendered since being with us," wrote Pershing to the Chief of Infantry when Eisenhower's detail to the commission expired. "In the discharge of his duties, which were most difficult . . . he has shown superior ability not only in visualizing his work as a whole but in executing its many details in an efficient and timely manner. What he has done was accomplished only by the exercise of unusual intelligence and constant devotion to duty." Ever after, Pershing was one of Eisenhower's most enthusiastic sponsors. In 1928, he asked that Major Eisenhower be again detached for service with the Commission for the purpose of revising the guidebook—and this turned out to be a most pleasant duty for Dwight and Mamie. They lived for a year in Paris, Eisenhower touring every battlefield in France on which Americans had fought and gaining thereby information that proved invaluable to him during World War II.

There followed a series of assignments, each more important than the last, leading directly toward the necessarily vague but high goal he had set for himself (at the instigation of Fox Conner). He became assistant executive in the office of the assistant secretary of war, engaged in shaping the aforementioned industrial mobilization plans (he was attending, at this time, the Army Industrial College). He became assistant to General Douglas MacArthur, Chief of Staff of the U.S. Army, then senior assistant to MacArthur when the latter went to the Philippines as Military Adviser to the Commonwealth; he was promoted to lieutenant colonel (permanent) while in the Philippines. Upon his return to the United States in December 1939, three and a half months after Hitler's invasion of Poland had launched World War II, he became executive officer of the 15th Infantry Regiment at Fort Ord, California, and, a few months later, chief of staff of the 9th Army Corps at Fort Lewis, Washington. On December 14, 1941, precisely a week after the Japanese attack on Pearl Harbor, Brigadier General Eisenhower (the rank was officially temporary) arrived in Washington where, very soon, he was Assistant Chief of Staff in charge of War Plans, in which capacity he served directly with and under General George C. Marshall, Chief of Staff.

His subsequent swift rise to world fame—as commanding general of the European Theater of Operations, as commander of the Allied invasions of North Africa and Sicily and Italy, as Supreme Commander of the Allied Expeditionary Force which crushed the Nazis in the west—is history known to all.

THE SUPREME ALLIED COMMANDER

In 1944 Dwight D. Eisenhower was named Supreme Commander of Allied Forces in Europe. Here he is shown speaking to American troops in Normandy that same year.

But for us in this book, the main point is that in the two decades that intervened between the two world wars, through all the very considerable periods of leisure time that characterized peacetime army life even for the most conscientiously hard-working of men, he never once turned to aesthetic pleasures for his recreation, so far as we know. Certainly he never touched paintbrush to canvas.

He remained as he had been during his Abilene youth and his four years as West Point cadet insofar as he preferred, and even needed, physical activity above all other kinds of "fun." He engaged in as much strenuous playing exercise as his injured knee would permit. He took up golf and became, as all the world knows, a lifelong and avid devotee of that game. He coached football and umpired baseball when the opportunity for doing so presented itself. He hunted. He fished. He worked with his hands (he had skillful hands) making things. On his visits to his Abilene home—and he came home for a visit of several days at least once in every year, save when he was stationed abroad—he laid the concrete foundation for a porch at 201 South East Fourth Street, fashioned a rose arbor in the backyard, built a sidewalk, put a new coat of paint on the barn.

His chief sedentary recreation was card-playing. In Abilene and on the Point he had played a great deal of poker, winning more often than he lost, and he continued to do so. He increasingly preferred bridge, however. A bridge player dealt in psychological warfare almost as much as a poker player, but success in bridge depended less upon luck and more upon accurate memory and logical skill. Eisenhower's was a notably logical mind with a capacious memory, quick and strong in the handling of concrete facts, beautifully controlled by his will. He displayed little interest in general ideas, however, and often a considerable irritation with vague abstractions. He still

displayed no active interest whatever in the arts.

He was almost totally absorbed in the task of preparing the outfits he served (as executive officer, as chief of staff) for battles overseas which he knew were coming. Not the least part of this task was psychological; he strove to convince his generally dubious colleagues, through long hours of vehement argument, that America's direct and active participation in the war was inevitable. He had still less recreational time after Pearl Harbor. In Washington he worked fourteen- and sixteen-hour days, chiefly on futile stratagems for the relief of Bataan and Corregidor, all through the winter and spring of 1942.

The same rigorous work schedule was required of him when he first took command of ETO and became a central figure in the incredibly confused planning for TORCH (the code name for the North African invasion); and when he moved to North Africa, where, in Algiers, he was beset by political problems as rasping to his nerves and demanding of his time as the problems of his purely military operations. Similarly, he had no leisure time when he directed the invasion of Sicily, then Italy, and had to deal with the political problems arising out of the collapse of Mussolini's power and the Italian surrender. And he had none in England after he returned there in January 1944, to preside as Supreme Commander over the completion of the huge and highly complex plans and preparations for OVERLORD (the cross-channel invasion of France).

Paradoxically, it was only after OVERLORD had been launched and he was "big news," a focus of world attention, as never before—it was while hundreds of millions around the world were reading his name in headlines, were hearing his name excitedly pronounced in newscasts morning, noon and night, and were imagining or accepting as unimaginable, indescribable, the hectic activities and tense excitements which

must prevail at the Supreme Headquarters—it was only then that a considerable measure of quiet and leisure, a freedom from immediate concrete pressures such as he had not known since his last days in the Philippines, was restored to his life.

For as Supreme Commander he saw only Very Important People who were directly involved in the great work at hand—and these were relatively few. He made only ultimate decisions, crucial decisions which might affect millions—and these, too, were relatively few and, moreover, required for their making relatively little time, since they were generally flat "yes-or-no" decisions. He was in the windless eye of the hurricane, or he was "at the still point of the turning world" (to quote T. S. Eliot), or he stood on the narrow lonely summit (there was only room for one) of a mighty mountain of action. Wide reaches of empty space and time were all around him. Too much space. Too much time. They tended to become crowded with pre- and post-decision anxieties, since he could not, in his unique circumstances, fend them off with card games to any great extent (only now and then could he arrange a bridge or poker session), could not socialize (he was isolated wherever he lived, in London and liberated Paris almost as much as in secret Telegraph Cottage or a secret caravan in an apple orchard in Normandy). He could not hunt, nor fish, nor play golf.

Then it was that he became more vulnerable than he had ever been before to a suggestion Winston Churchill must have made to him—implicitly if not explicitly, by example if not in words—during Churchill's visits with Eisenhower in North Africa (where Eisenhower may well have witnessed a Churchillian "attack" upon canvas), and at the "advance base" in Portsmouth during pre-OVERLORD days, or during Eisenhower's weekly dinners at No. 10 Downing Street, and on occasional weekends at Chequers. There were now long periods of

empty time during which the Supreme Commander would have welcomed a diversion as absorbing and delightful as the prime minister obviously found painting to be.

Churchill has told, in *Amid These Storms,* how he happened to take up painting in the first place. It was in the early summer of 1915 when his political fortunes, along with his general popularity, were at their lowest ebb in all his long career of ups and downs. As First Lord of the Admiralty during the early months of World War I, he had pressed for a British attack upon the Gallipoli Peninsula, conceiving it as a masterstroke that would lead to decisive results while the Germans and Allies faced one another in bloody stalemate on the Western Front. The attack had been fatally mismanaged. And for the resultant bloody repulse of the British landing force, which caused the fall of the government of Prime Minister Asquith and the formation of a coalition government under Lloyd George, Churchill was held more responsible than any other public figure. He was included in the new cabinet (doing so required some hardihood on the part of Lloyd George), but he was emphatically out of the Admiralty, and though he remained a member of the War Council he had no executive authority. He was, at best, a mere consultant upon whose advice fell the discrediting effects of the Gallipoli disaster.

His was a maddening position, and especially so for one of his temperament. He was privy to all the information, secret and otherwise, on the basis of which decisions were allegedly made, yet was denied any truly effective participation in the decision-making process. He must watch with an intimate vision while projects he had initiated at the Admiralty and *knew* to be worthy of major commitments were abandoned or so meagerly supported that they were doomed to failure, yet

The allied invasion chiefs discuss "Operation Overlord" at a press conference in their London headquarters in 1944.

could do nothing about them. He had abundant reason, in these circumstances, to become concerned about his mental health. Intense nervous energies, backed up along his nerve fibers by continuous frustration threatened to burn them out, "blow a fuse" that would knock him out altogether. It was at this danger point, as he has written, that "the Muse of Painting came to my rescue—out of charity and out of chivalry, because after all she had nothing to do with me. . . ."

On a Sunday in the country, during one of those "long hours of utterly unwonted leisure" in which, for lack of compelling diversion, he was "forced to contemplate the frightful unfolding of the War," he happened upon the paint box of his children —water-colors, one assumes—and began to experiment with it. He was intrigued. Water-color painting, with its finicky stroking and intolerance of error, was clearly not for him, but he wondered if oil painting might not be. He decided to find out. Next morning he procured "a complete outfit for painting in oils"—tubes of color, a palette, an easel, canvases, a variety of brushes—and promptly set it up to begin a painting.

At this point, according to his own account, he was stymied— and we know that he imparted to Eisenhower something of the nature of this experience, if not its full story, for Eisenhower later referred to it when speaking of his own initial painting efforts. Churchill found himself staring helplessly at the blank canvas. The canvas glared back intimidatingly. Only after long hesitation, and then very tentatively and with a very small brush, did Britain's lion of war manage to sully the white purity before him with a very small touch of blue. He then stared again, more helpless than before. He might soon have confessed total defeat but for the fortunate arrival at that moment of a visitor, a very talented lady, who scoffed at his hesitancy and shamed him out of his cowardice by seizing the very largest

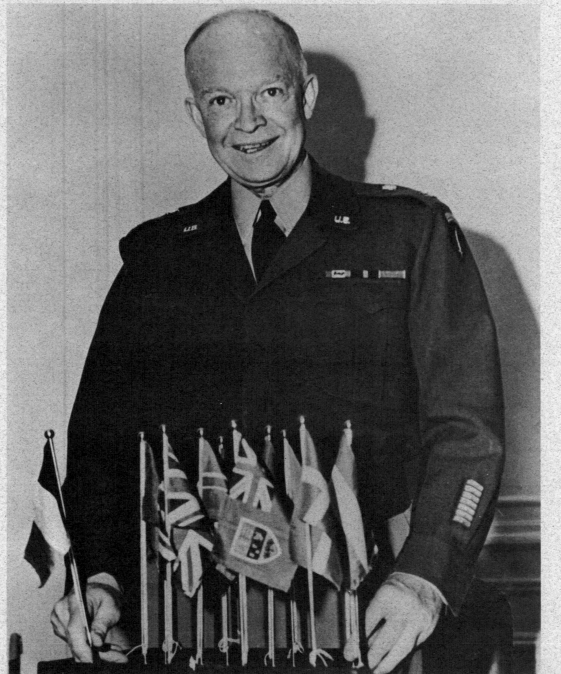

Above, the general and his son John are shown together in Korea. Left, on April 2, 1951, having returned to active military duty, General Eisenhower assumed command of SHAPE (Supreme Headquarters, Allied Powers, Europe), which had the responsibility of creating effective military forces for NATO.

brush, splashing it into turpentine and paint, and literally walloping the canvas with a series of slashing strokes. To Churchill the canvas now seemed to be "absolutely cowering." It "grinned in helplessness before me. . . . I . . . fell upon my victim with berserk fury. I have never felt any awe of a canvas since."

It is perhaps more revelatory of Churchillian psychology than of the essential quality of art *per se* that he should regard an artist's painting of a good picture as analogous to a general's fighting of a victorious battle. In both cases a sound plan based on a thorough reconnaissance of the country to be fought over is necessary, said he. In both cases there is need for a strong reserve. In both cases "audacity" is of prime importance to success. And one suspects that he described painting to General Eisenhower in these terms during one of Eisenhower's visits to Downing Street or Chequers, showing the general some of the canvases he had completed as well as the one that happened to rest at that moment incomplete upon his easel. At any rate, in the summer of 1968, when former-President Eisenhower was interviewed on tape as he toured the Exhibition of Eisenhower Paintings and Memorabilia sponsored by Eisenhower College in May 1967, in New York City—an exhibit including more than one hundred of his "daubs," the first occasion for him to see more than five paintings together, due to his propensity to give them away even before they were finished— and was asked if Churchill had taught him anything about painting, he replied that he had had one valuable piece of advice from the wartime prime minister. It had to do with that awesome moment when one stands, brush in hand, before a canvas of arrogant aristocratic pallor. As translated into Eisenhower language, Churchill said: "Look, don't be afraid of the darn thing. Go ahead and do it. Just take a brush and start putting something on the canvas."

In recognition of General Eisenhower's victorious leadership, nations all over the world awarded him their highest honors. Pictured is an impressive display of some of these decorations and the various war medals he received during his career.

109

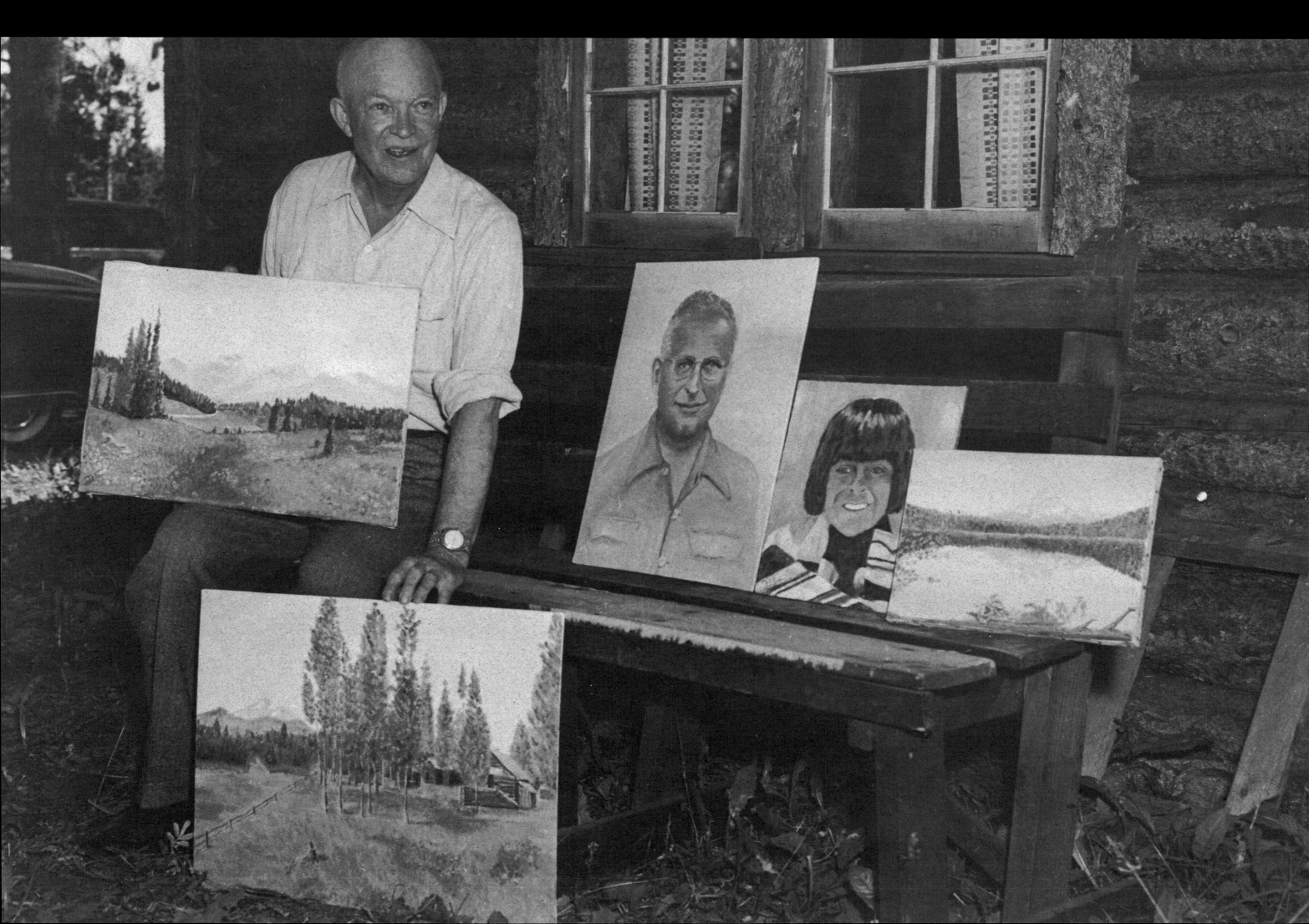

PART VI

THE ARTIST EMERGES

Less dramatic than Churchill's, yet amid psychological circumstances somewhat similar to those of Churchill in the summer of 1915, was Eisenhower's initiation into painting.

He had not yet touched brush to canvas when, with Nazi Germany crushed, he dissolved SHAEF (Supreme Headquarters, Allied Expeditionary Force) in July 1945, and became commander of the United States zone of occupation in Germany. Nor had he done so when he returned to Washington, D.C., in the fall, to take over (November 19, 1945) as Chief of Staff of the U. S. Army. He still had not done so when, several months later, the present author (having recently published a full-length biography of Eisenhower, *Soldier of Democracy*), spent an afternoon alone with him at Fort Myer.

Perhaps because his visitor was a native Kansan who had worked with and immensely admired Milton Eisenhower (Milton was then president of Kansas State University, his alma mater)—perhaps, too, because his visitor's book had stressed the Abilene and family influences upon the young Dwight Eisenhower—the general's mood that day was predominantly reminiscent, retrospective. He talked with surprising frankness about several historic figures with which the biography had dealt (Marshall, Montgomery, and Patton particularly), comparing his own judgments of these men with those the author had made, and he talked with equal frankness and a wholly disarming modesty about himself, discursively, as if he sought to come to terms with, to understand, a career he thought of in past tense, a career whose peak, he obviously believed, had been reached and passed. But had it been passed? his visitor asked. What about all this talk of him for president in 1948? He dismissed such talk emphatically.

He had spoken earlier of the obligations, which he obviously deemed to be moral obligations, imposed upon him by his great fame—a fame whose dimensions had surprised him during the triumphs accorded him in Europe and America in June 1945, and which he certainly did not regard as his private property. ("Humility must always be the portion of any man who receives acclaim earned in the blood of his followers and the sacrifices of his friends," he had said in his justly famous Guildhall address during his London triumph.) Instead, he seemed to regard his fame as a kind of immense energy generated by the dreams and wishes, the goodwill and generous aspirations of myriad millions of people, most of them common folk like the Eisenhowers of Abilene in the first two decades of the century. This energy had become focused upon him by historical accident, transforming him into a symbolic person. A mass symbol. And what he symbolized, he thought, he who had been the principal architect of SHAEF—that unique instrument of international cooperation in war—was unity for peace, a unity not just of Americans. However, that day he was much concerned about a threatened resurgence of isolationism and was determined to do what he could to counteract it. He wanted unity of all people everywhere who yearn for freedom, in a world organized economically and politically to permit each individual to realize his or her full potential as a human being.

"But," he now said, "suppose I gave in to these people who come here in delegations—and they come from both parties—begging me to permit them to run me for president? Immediately I'd lose my value as a unifier of people. Immediately about half the people who are for me now because I stand for something they believe in would be against me." He paced the floor, gesturing, as he said this. "I am *not* going to do it," he concluded to his questioners.

To reporters in Abilene in June 1945, on the occasion of his triumphant return from the war to his hometown, he said: "In

(Continued on page 145)

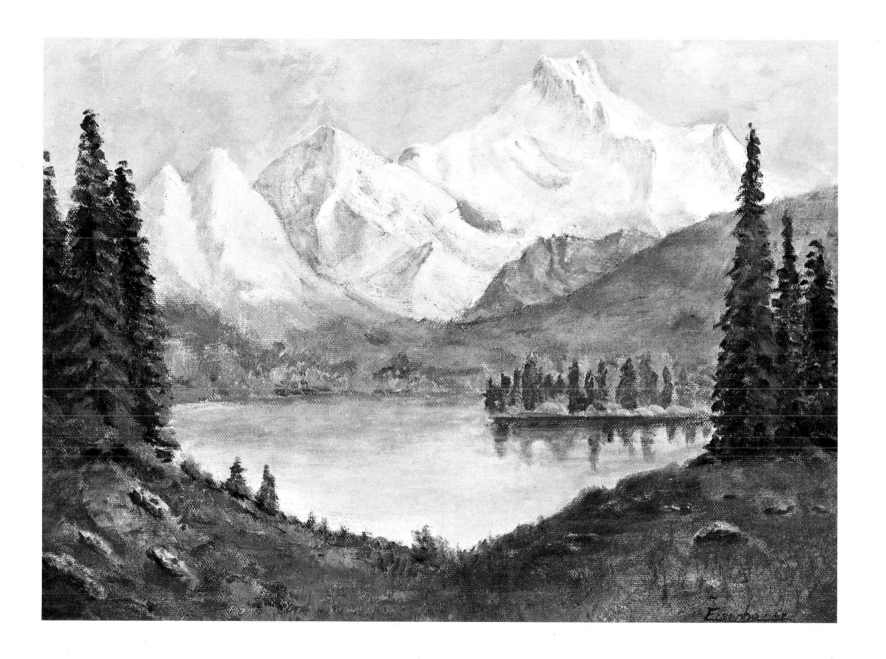

PLATE 35

MOUNTAIN LAKE

From the collection of Mr. and Mrs. William E. Robinson, Greenwich, Connecticut. That Eisenhower painted this picture from memory cannot be doubted, for he painted it in Augusta, Georgia, in April 1956, during his presidency. The mountains are unmistakably Alpine and similar to others he painted. His use of the curvilinear outline of the lake in dead center is unique in his compositions. 12 x 16 inches.

PLATE 36

FRANCES DOUD MOORE

From the collection of Mrs. Frances Doud Moore, Belaire Beach, Florida. Eisenhower truly captured the elegance of a fine lady, his sister-in-law, in this portrait which he presented to her in February 1953. The simplicity of the cool gray-green background and black dress contrast beautifully with the warm colors of the face, elegantly illuminating it as the central focal point of the portrait.
16 x 20 inches.

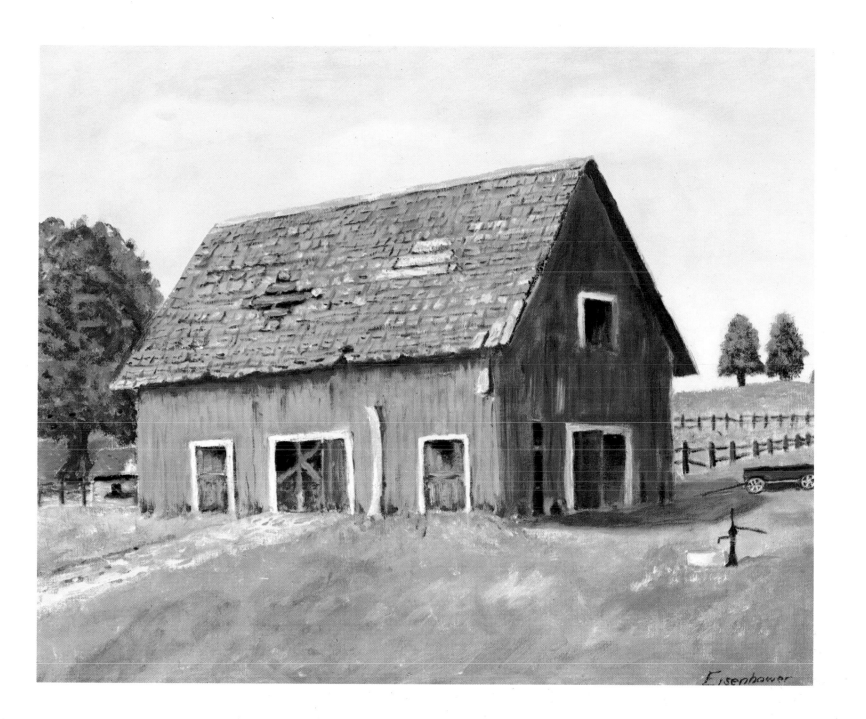

PLATE 38

THE
RED
BARN

From the collection of
Chief and Mrs. Walter A. West.
Eisenhower painted this barn
in 1958 during his presidency;
an earlier one was done in
August 1955. He had this
painting reproduced as a
Christmas card for members of
the White House staff and
friends of the First Family.
Details of the hand pump,
lower right, the fading color
of the barn and the dilapidated
roof are no doubt reminiscent
of early days in Kansas.
16 x 20 inches.

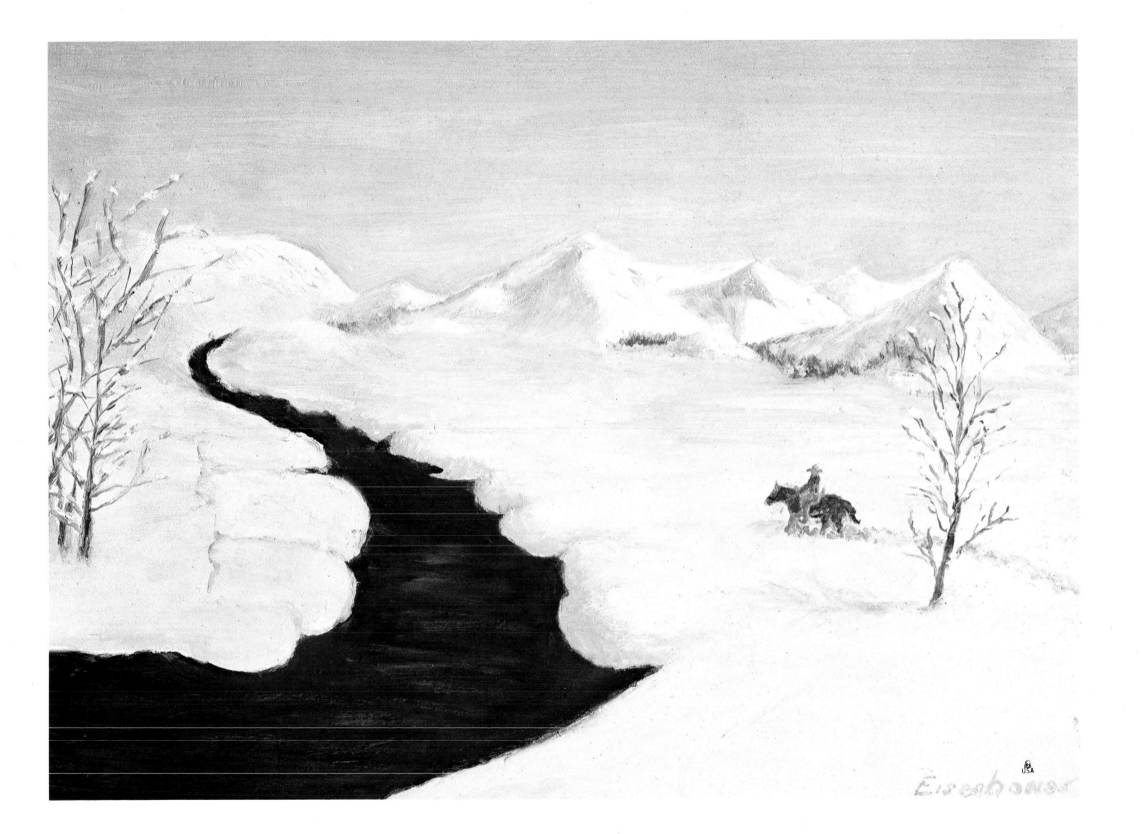

PLATE 39

LONELINESS

From the Eisenhower College
Collection, Seneca Falls, New
York. The stark darkness of
the winding stream, contrasted
with a preeminently white
background, distinguishes this
painting from others by
Eisenhower. Its individuality
lies in the pattern made
by the small river.
14 x 18 inches.

PLATE 40

HOUSE AND SNOW-CAPPED MOUNTAINS

From the collection of Mr. and Mrs. Michael Gill. The texture of a very coarse canvas has been utilized to achieve an overall graininess with a thin (sometimes very thin) application of paint. Warm yellows and yellow greens give the composition its sunny atmosphere. 8 x 10 inches.

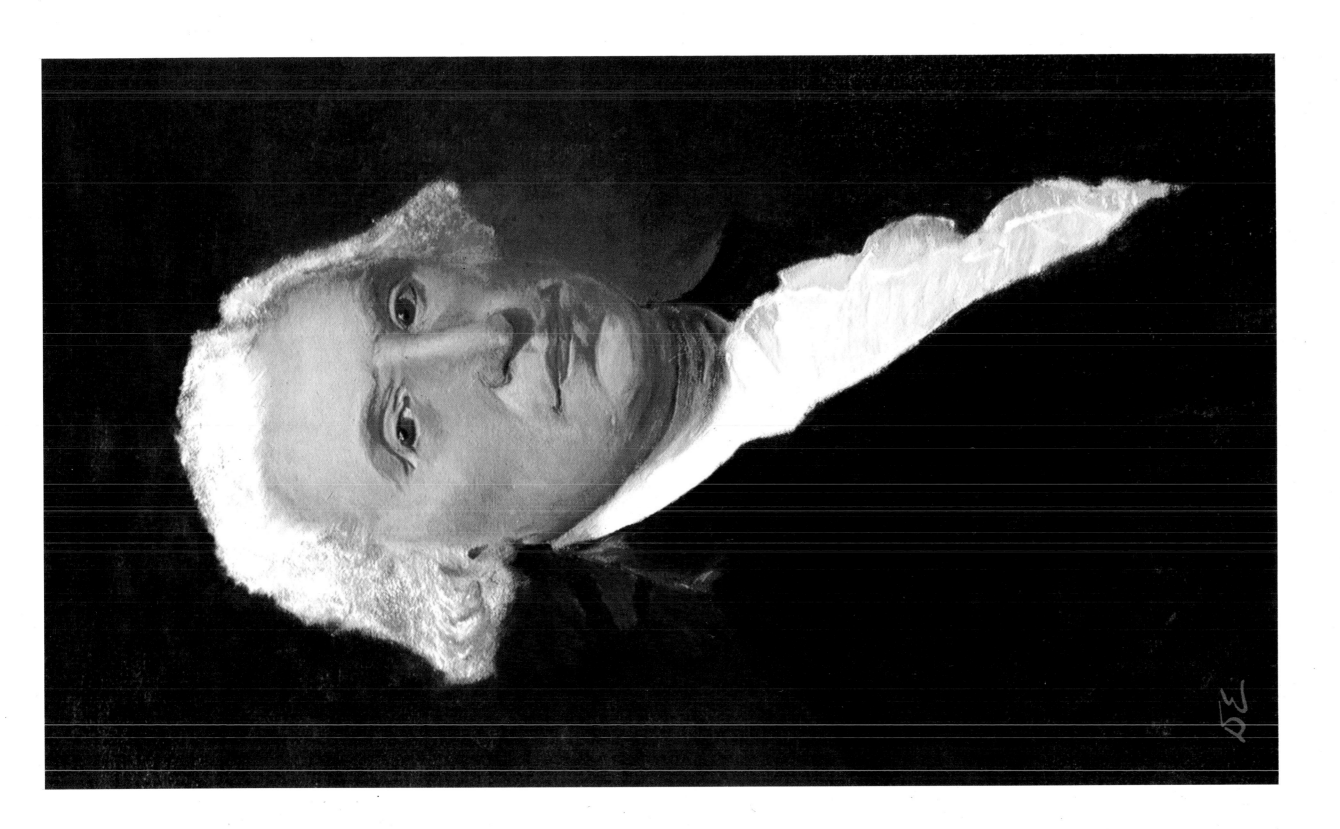

PLATE 41

GEORGE WASHINGTON

From the collection of Mr. Robert W. Woodruff, Atlanta, Georgia. Eisenhower painted the picture from the famous Gilbert Stuart portrait in 1959 during his presidency and presented it to Mr. Woodruff. He held Washington and Lincoln in equal esteem. 30 x 25 inches.

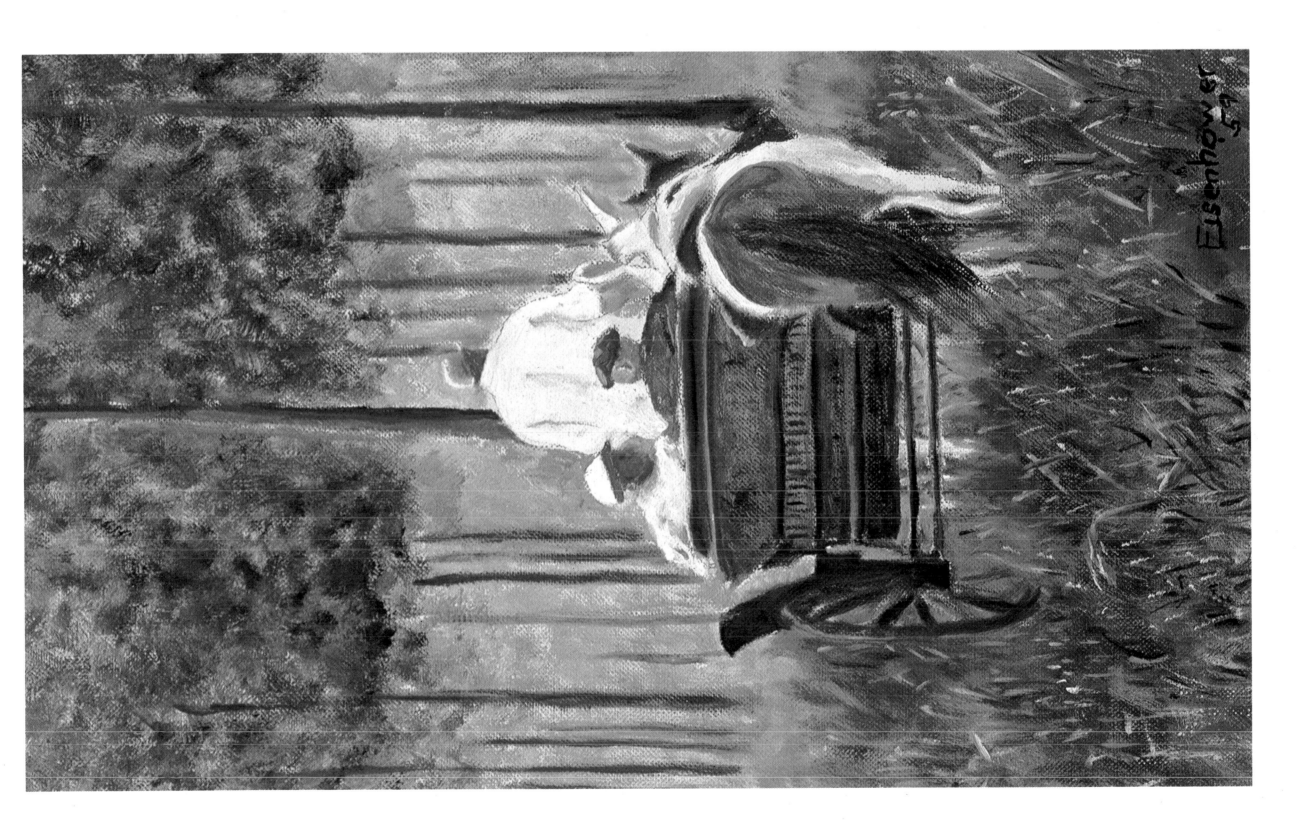

PLATE 42

HUNTING
WAGON
IN
GEORGIA

From the collection of The
Honorable and Mrs. George M.
Humphrey, Cleveland, Ohio.
Here Eisenhower has depicted
himself and his friend George
M. Humphrey from memory as
they are seated in a shooting
buggy at Milestone Plantation,
Georgia. He painted it in 1959
and presented it to Mr. Humphrey.
19¾ x 15½ inches.

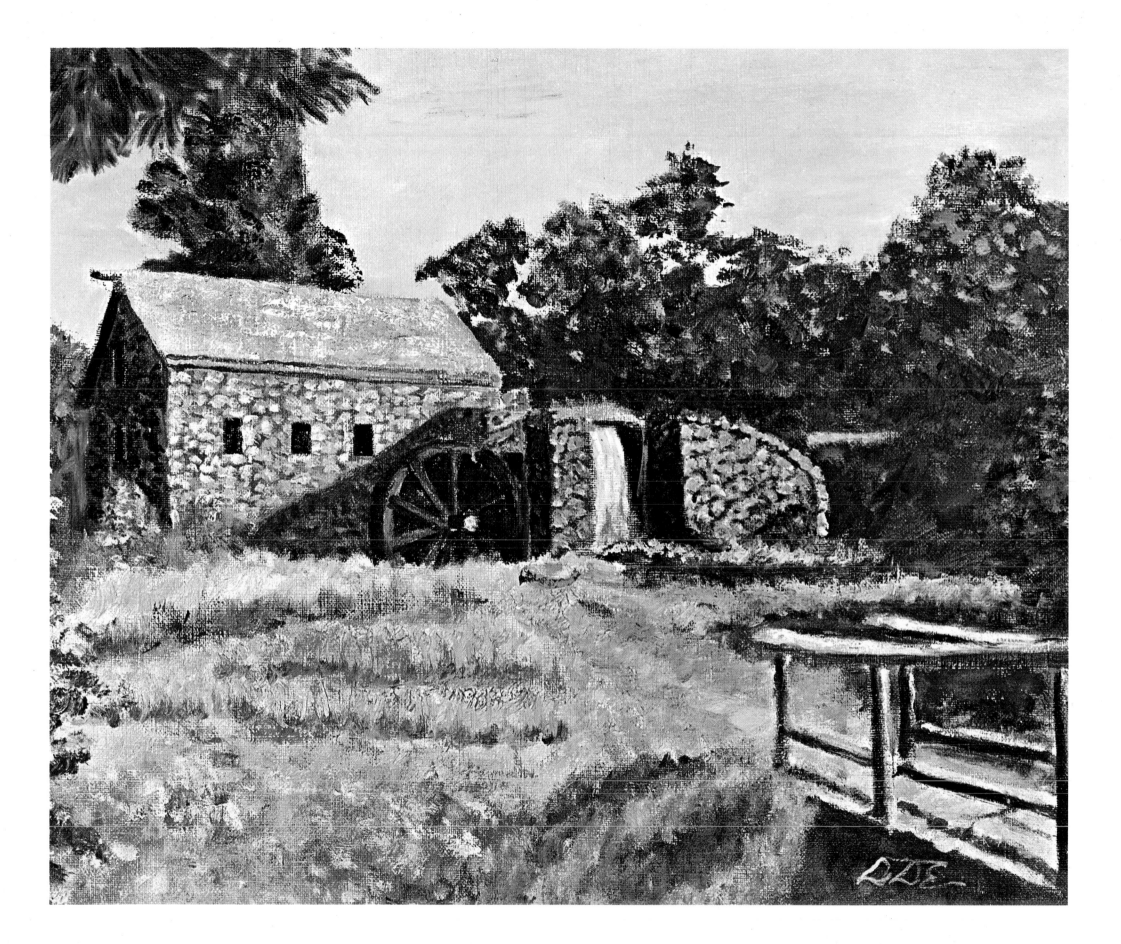

PLATE 43

OLD MILL

From the collection of
Mrs. Steven J. Rees.
Sunlight pervades the
canvas, casting convincing
shadows on the old mill.
Allowing bits of white canvas
to show, uncovered by paint,
in the foliage of the trees has
given the painting an aura
of rural airiness. This is
a technique Eisenhower did
not employ generally.
His effective use of the
palette knife is demonstrated
at lower left.
12 x 14 inches.

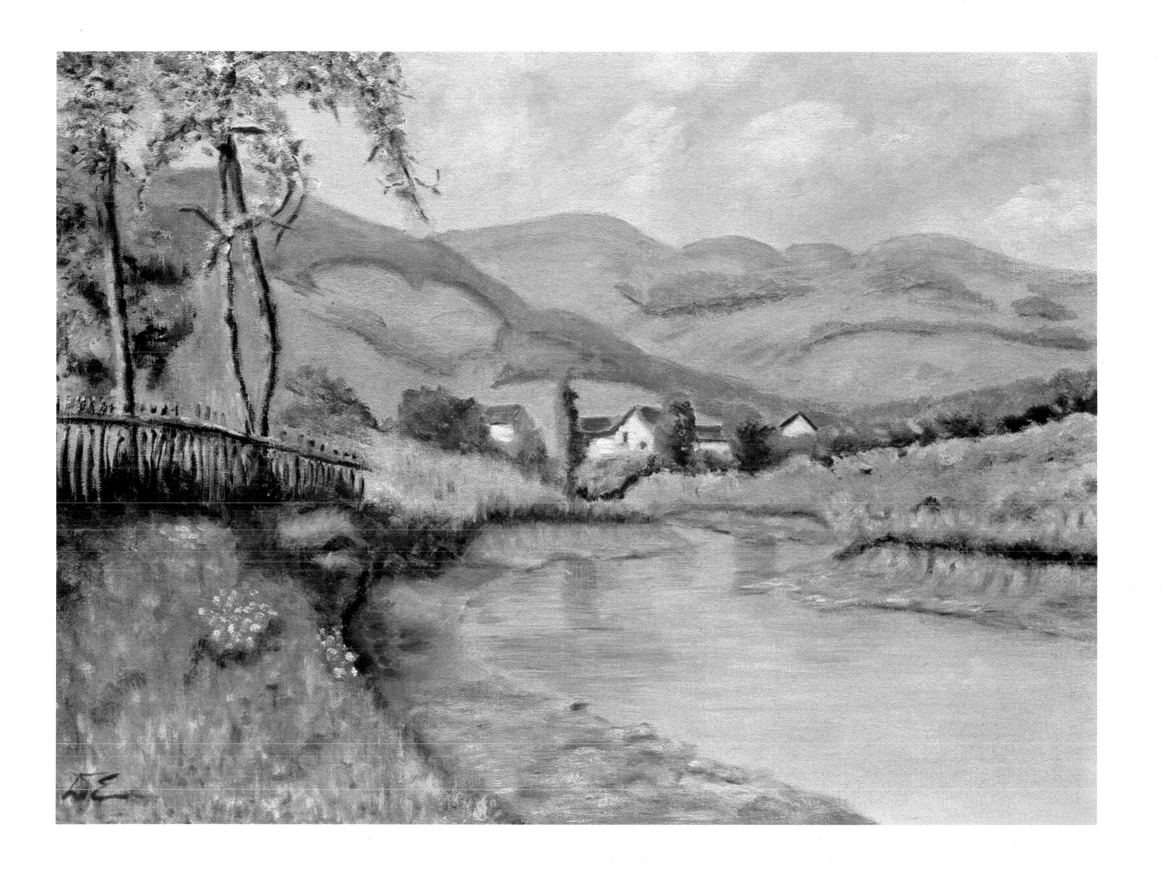

PLATE 44

A PASTORAL SCENE

From the collection of
Dr. and Mrs. Milton S.
Eisenhower, Baltimore, Maryland.
Painted in the early 1960s
especially for his brother
Milton, the reverse of the
canvas is inscribed with
"To M.S.E. from D.D.E."
Low-keyed colors and a
smoothness of painting technique
make the oil appear to be
a pastel, even at close range.
Eisenhower himself was
pleased with this quality
in the painting.
18 x 24 inches.

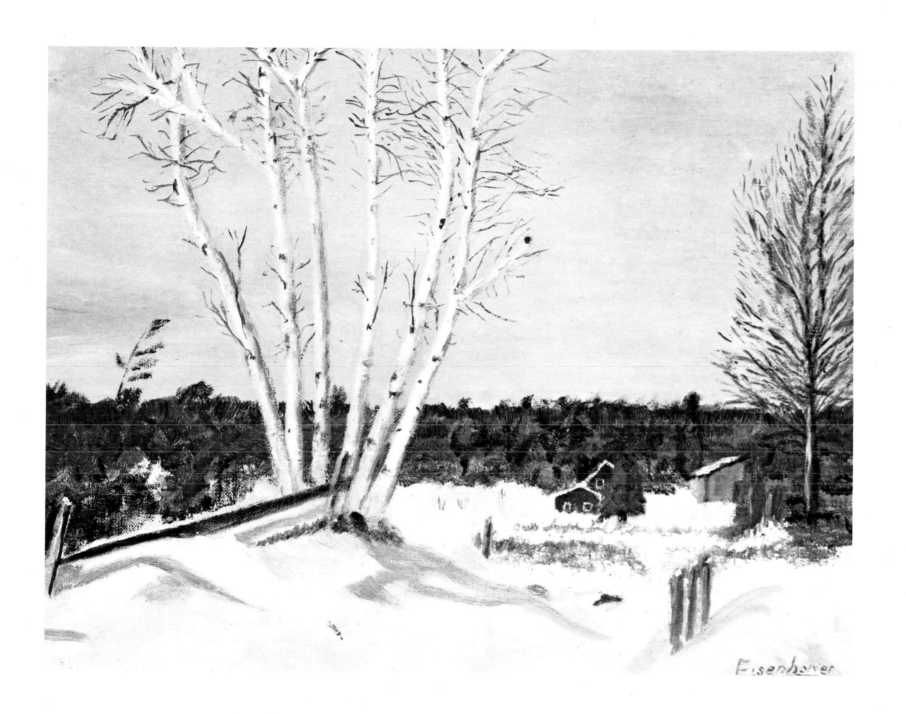

PLATE 45

WINTER BIRCHES

From the collection of
The Honorable and Mrs. Floyd
Odlum, Indio, California.
The meticulous detail of
the small, bare branches of
the birch trees forms an
intriguing pattern against a
cloudless sky. As he does in this
picture (the red buildings and
one evergreen tree), Eisenhower
frequently used bright spots
of color as focal points.
14 x 18 inches.

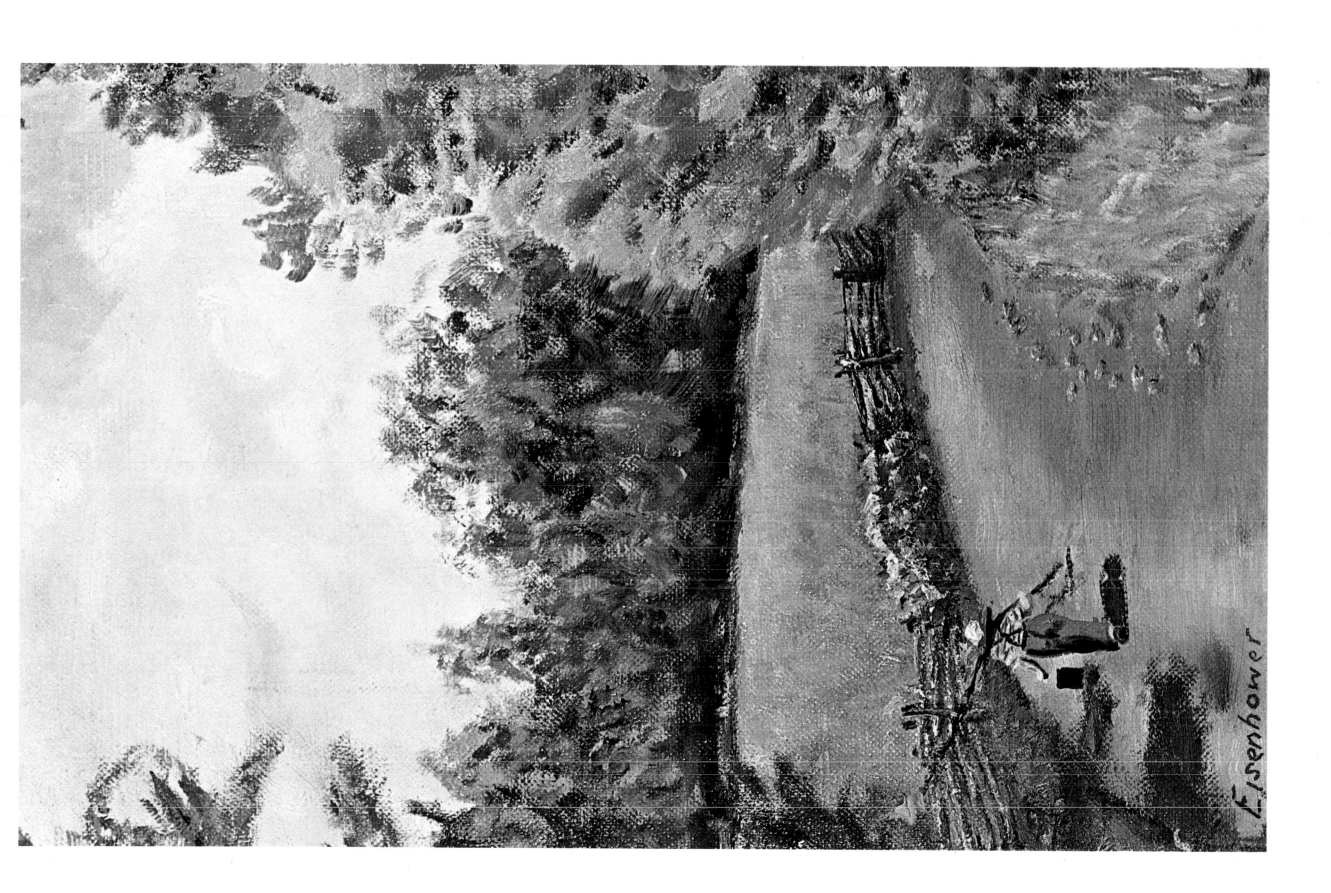

PLATE 46

A
COUNTRY
ROAD

From the collection of Mr. and Mrs. Leigh M. Battson, Beverly Hills, California. The charm of the painting can be attributed almost entirely to the whimsical figure of a small lad, fishing pole on shoulder and bucket in hand, making his way down a winding country lane to a fishing hole. 14 x 11¼ inches.

Eisenhower

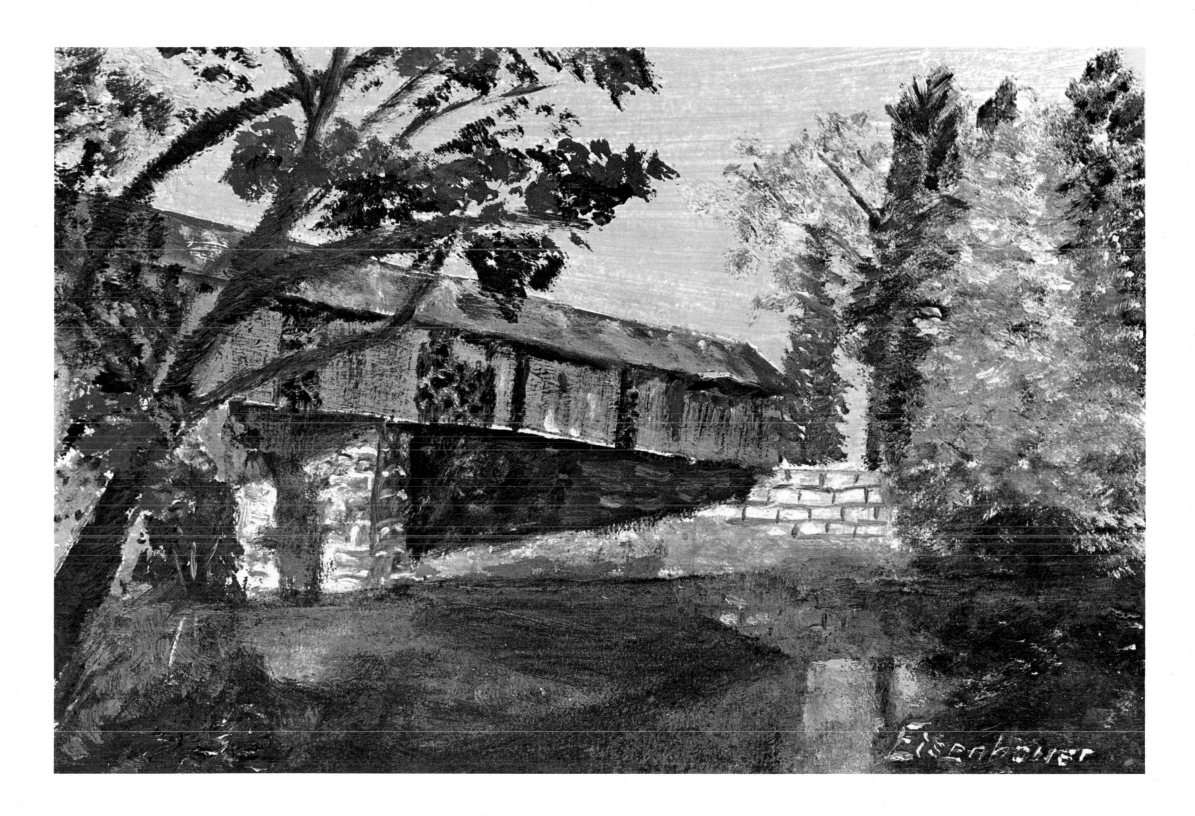

PLATE 47

LONG COVERED BRIDGE

From the collection of The Honorable and Mrs. Edward L. Ryerson. An astonishing amount and degree of detail has been put into a quite small painting. Leafage and other growth has been partly stippled with a tiny, stiff-bristle brush. Brilliant reds assist in lending perspective to the distant covered bridge, low in color key.
5 x 7½ inches.

PLATE 48

MONASTERY

From the collection of General and Mrs. Alfred M. Gruenther, Washington, D.C. Although undated, this is said to be an early painting, which automatically inspires admiration for the effective perspective, chiaroscuro and the feeling of movement with the walking monks' flowing habits. 16 x 10 inches.

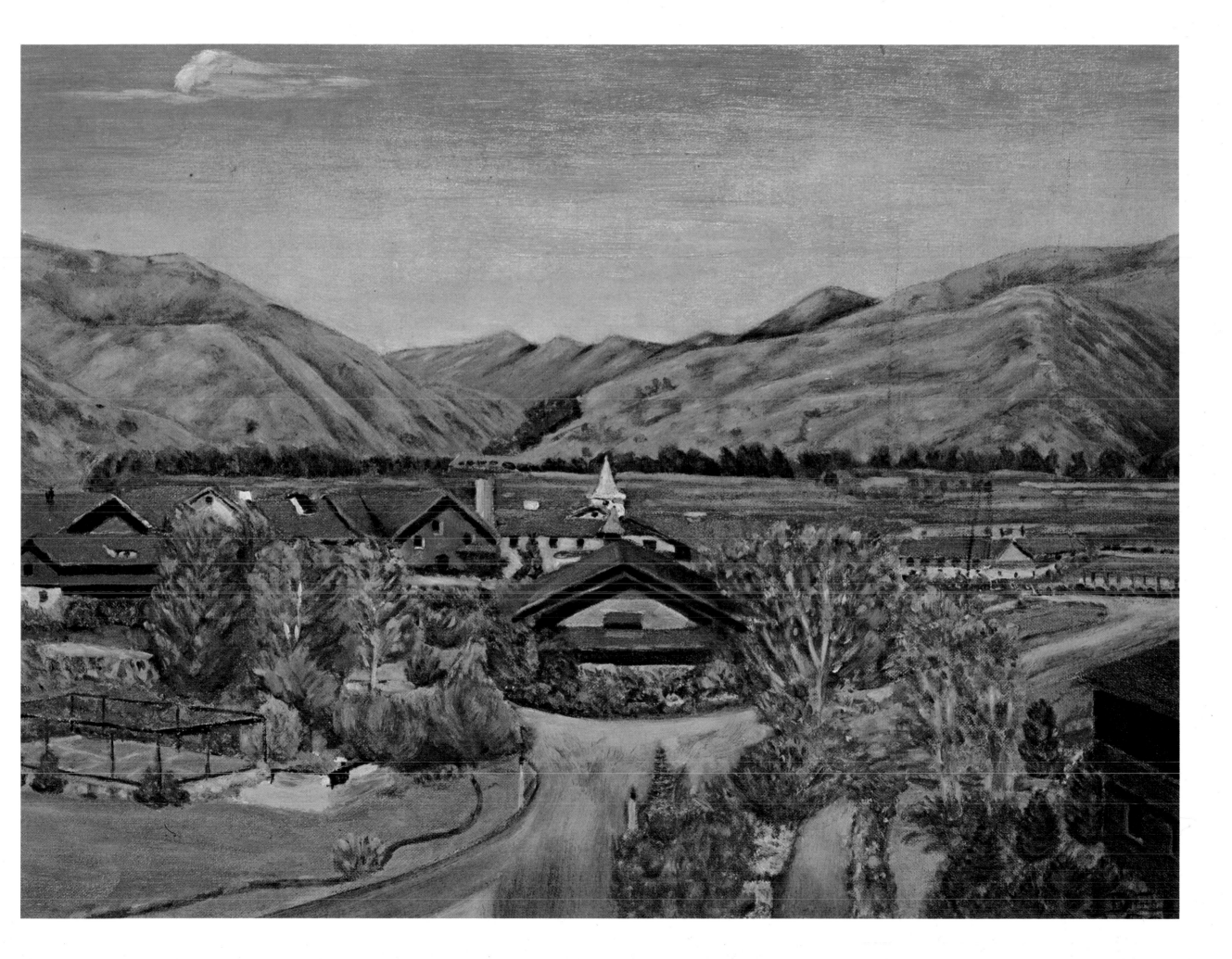

PLATE 49

VILLAGE IN THE VALLEY

From the collection of
The Honorable and Mrs.
Averill Harriman. The
year of execution of this
pleasant valley scene is not
known. That it is an early
painting would be a logical
conclusion. The greens are
less gradated and muted than
in other paintings and he
has not employed the variety of
painting techniques seen
in other works.
16 x 23 inches.

PLATE 50

CAMP DAVID

From the collection of
Mr. and Mrs. David Marx.
With careful color selection,
gradations of green, flecks of
bright yellows, and shadows of
the overhead tree foliage on
a lemon sward, a quiet
seclusion and privacy permeates
the canvas. Eisenhower spent
many happy as well as important
hours here, but somehow his
recreational use of Camp David
seems to have been foremost in
his memory with this painting.
14 x 20 inches.

the strongest language you can command you can state that I have no political ambitions at all. Make it stronger than that if you can. I would like to go further even than Sherman [who said that if nominated he would not run, if elected he would not serve] in expressing myself on this subject."

And he clung to this decision for the remainder of that year and all through the next while pressure upon him to enter presidential politics continued, incessantly, increasingly.

In a public letter to a New Hampshire newspaper publisher who, in a fanfare of publicity had urged him to enter the New Hampshire Republican primary, Eisenhower (January 28, 1948) expressed his conviction that "the necessary and wise subordination of the military to civil power will be best sustained, and our people will have greater confidence that it is so sustained, when lifelong professional soldiers, in the absence of some obvious and overriding reasons, abstain from seeking high political office." Politics, he continued, "is a profession; a serious, complicated, and, in its true sense, a noble one. In the American scene I see no dearth of men fitted by training, talent, and integrity for national leadership. On the other hand, nothing in the international or domestic situation especially qualifies for the most important office in the world a man whose adult years have been spent in the country's military forces. At least this is true in my case."

Obviously he meant what he said. The previously loud talk of him for president died abruptly to a whisper.

But a few months later the talk was not only renewed but also augmented in volume and urgency by the announcement that he had accepted the presidency of Columbia University, succeeding the late Nicholas Murray Butler who, throughout his long university career, had been notoriously perennially "available" for the Republican presidential nomination.

There is abundant evidence that the general was decidedly uncomfortable in his academic role. The chapter of his memoirs, *At Ease,* telling how he happened to accept the post and of his personal life in the president's ornate mansion on Morningside Heights, is called "New Student in an Old University" and is apologetic in tone. He writes that when first approached by Columbia's Board of Trustees, he told them "that they were talking to the wrong Eisenhower. My brother Milton was uniquely fitted...." And a story current at the time in academic circles was that Milton was the inadvertent cause of the general's being considered for this post. The trustees were said to have asked Robert Maynard Hutchins of the University of Chicago to name a man who might succeed Butler, and Hutchins named "Eisenhower," meaning Milton, whom he much admired and had tried to persuade to come to Chicago as vice president. This suggested the general to the trustees, who might otherwise never have thought of him as a possibility.

He displayed unprecedented self-doubts as he dealt with a faculty studded, as he writes, with " 'Names' in every field of human knowledge and research," and with a student body whose leading elements were sharply critical of him from the first. One sensed at the time, in his public words and acts (these seemed more and more to be those of a Republican presidential candidate), that he had lost some of the hard integrity which had characterized him in the army, where he was self-confidently on top of every part of his job; that he had become a deeply divided man, uncertain of what he, as symbol, now stood for, or *ought* to stand for; that he was increasingly unable to distinguish between "duty" and "ambition" when presented with the most difficult career choice of his life; and that, in consequence, he was losing control of his own destiny, was being swept helplessly into a stream of events that bore him willy-

Eisenhower changed his military uniform for civilian clothes in 1948, after being appointed the new president of Columbia University in New York City.

nilly toward the elective politics he wished to avoid.

It was at this point, significantly, that he took up painting as a pastime.

One day, not long after the Eisenhowers were none-too-comfortably housed amid the formal oak-and-marble grandeurs of the presidential mansion at 60 Morningside Drive, an artist, Thomas E. Stephens, came to paint a portrait of Mamie. Eisenhower watched, fascinated, all through Mamie's first sitting, remarking enviously upon the artist's skill and evident pleasure in the task at hand. Would that he himself could derive as much sheer joy from his own task at hand! Doubtless in his mind, too, if below the level of consciousness, were the counsels of Churchill, who had so often spoken, almost in the accents of morality, about the "first importance" of "the cultivation of a hobby and new forms of interest" by people "who, over prolonged periods, have to bear exceptional responsibilities and discharge duties upon a very large scale"—these counsels, along with the remembered examples of Churchill absorbed at his easel, Britain's Harold Macmillan and Sir Alan Brooke bird-watching on North African beaches, Franklin Roosevelt with his stamp collection in the White House. The sitting ended, Mamie and the artist left the room to go over the house in search of precisely the right place in which to hang the portrait when it was completed. Eisenhower was left alone. He examined the canvas. He picked up the artist's palette, still glowing with fresh paint colors left over from the sitting. At that moment there entered the room the sergeant who had long served him, and on sudden impulse he asked the sergeant to help him improvise a "canvas" out of a small wooden box with its sides knocked out and a clean white dustcloth stretched and tacked to the box's frame. On this he began to copy Mamie's unfinished portrait, using Stephens's brush and palette. He was

On the eve of the presidential election, November 4, 1952, confident of victory, Eisenhower makes the familiar "V" sign. The following day the returns confirmed that an unprecedented number of votes were cast and he carried all but nine states.

still hard at it when Mamie and the artist returned. The three of them "laughed heartily" over what Eisenhower later described as a ludicrous effort (Mamie pointed out that the small pink bow she was wearing in her hair had grown to relatively monstrous proportions on her husband's small "canvas") but which the artist thought was surprisingly good for an absolutely first attempt and asked to have as a keepsake.

"You ought to take up painting," Stephens said, quite seriously.

A day or two later, Eisenhower received as a gift from Stephens a complete oil-painting outfit. He carried the large opened package to his room where, for several days thereafter, it simply sat in a corner staring at him rather accusingly whenever he entered, for it was an expensive as well as a thoughtful present for Stephens to have given and one hated to deem it wasted. Then it began to beckon him with invisible fingers of curiosity, and with more and more urgency, until one day, as he says, he "took the plunge."

Atop the mansion's formal grandeurs was a wooden structure of modest size and severe plainness. It had once contained a water tank for the mansion's emergency use, but had since been remodeled into a kind of penthouse. It could be reached only by means of a tiny and rather rickety elevator and seemed to Eisenhower and Mamie, who promptly made it their retreat "from the insistent demands of official life," almost as remote from the great city around them as if it had been an island in the sky. And, indeed, the sky was there all around them; its moods were more completely dominant over every view from the penthouse windows than were the moods of a Kansas sky over views from a lonely house on the High Plains.

It was to this retreat that Eisenhower took Stephens's gift. He set up his easel on a tarpaulin of generous size spread upon the floor to catch the paint which, in his "messiness," he generously splattered, and began to paint, in spare moments, virtually every day. The moments tended to lengthen into hours. At first he copied photographs and reproductions of other paintings exclusively—photographs of faces, photographs of landscapes—and nearly all of these he destroyed. Then he tried painting live portraits of Mamie and others (his grandchildren when they came), several of which he presented as gifts, often if not generally jokingly, to their subjects. And, simultaneously, he began painting landscapes "on site" when occasion offered, and painted a considerable number of them, though "with magnificent audacity," as he says in *At Ease,* he continued to paint "more portraits than anything else." ("I've also burned more portraits than anything else," he added.)

He found his new hobby more and more absorbing, more and more delightful, a total relaxation from the tensions of his official duties and the anxieties of career decision, just as Churchill had indicated it might be. It was more so than golf, really; golf continued to be his favorite recreation. He was a rainy day painter rather than a Sunday one, fair Sundays being golf days for him. But he had to admit that a missed putt or a hooked drive into the rough often bred an anger, a disgust, a species of anxiety from which painting in the carefree way he practiced it was happily, utterly free. Nor was the delight born of this pastime limited to his painting hours. He discovered in himself a passion for color and a sense of line and form which he had not known he possessed, and these stimulated his vision in ways that opened up a whole new world before his eyes. He saw more sharply and variously, with finer, subtler distinctions between this color tone and that, this sweeping curve and that somewhat flatter one, than he had ever seen before. "Sometimes I'll take two hours to get just the shade I want of, oh, a raft out

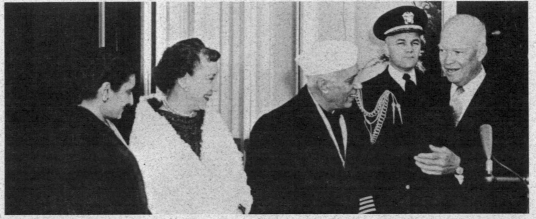

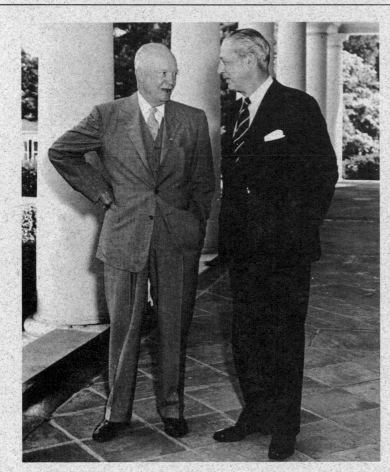

During his second term as president, Eisenhower met often with international heads of state, and in his last two years in office embarked on a series of goodwill trips. Above right Eisenhower greets Prime Minister Nehru and Mrs. Gandhi in India in 1956. The following year he visited with Queen Elizabeth of England (middle right) and in 1958 with Prime Minister Macmillan (directly above). In 1959 the president met Russia's Khrushchev (top left), and with Mamie in 1960, he met with French President Charles De Gaulle (right), his old wartime ally.

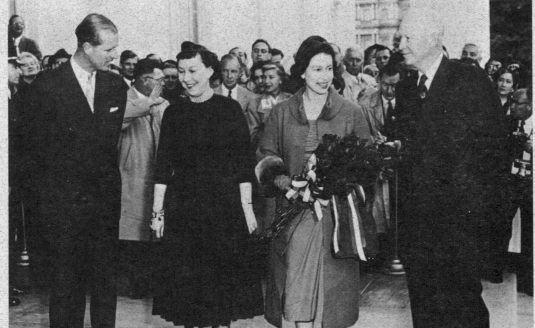

there, or a tree," he once said to an interviewer. And when he looked at other people's paintings now it was with an appraising eye, an eagerness to discern how the work had been done, how the colors had been mixed and the brush applied.

He had been at Columbia only a little more than two years when he was offered an honorable means of escape from his duties. President Truman asked him to assume Supreme Command of the North Atlantic Treaty Organization, a post for which he knew himself to be better qualified than any other man in the world, and he happily accepted it, having requested and been granted by the trustees a leave of absence from the university. He and Mamie moved to Paris, where NATO was headquartered, and his painting outfit went with him. In Paris he painted, among many other pictures, a portrait of Field Marshal Bernard Montgomery, who was Britain's top representative in NATO, presenting it to Monty after inscribing on its back, ". . . by his friend Ike." (Years later, after Eisenhower had died, Lord Montgomery sold the painting at auction in London, having expressed the hope it would go to an American buyer who would display it in the United States. It was bought by Walter Annenberg, President Nixon's ambassador to the Court of St. James; was presented to Prime Minister Harold Wilson during a visit Wilson made to Washington; and is now hung, "permanently," in the British embassy in Washington.) Eisenhower had a painting on his easel constantly, one after another, all through the period of steadily increasing pressure which culminated in his rather ambiguous announcement, on January 6, 1952, of his "availability" for nomination as Republican candidate for president at the Republican Party Convention in July.

He had little time in which to paint after he resigned his NATO post in the late spring and returned to the United States

(his home was still 60 Morningside Drive; he was still officially president of Columbia) to engage in an intense preconvention campaign against Senator Robert Taft of Ohio for the nomination. He had even less painting time during his campaign for the presidency against the Democratic nominee, Adlai E. Stevenson. But it is recorded that on November 4, 1952, on Election Day, weary from the campaign, he went up alone to his penthouse retreat and there painted when he was not napping through most of what history might regard as the most crucial day of his life.

His paint box, his brushes, his easel accompanied him into the White House, by which time (and for the first time, between Election and Inaugural days) his painting hobby had become national news. He established a "studio" on the second floor of the White House in a small room, hardly more than a closet, next to the elevator. Here he had complete privacy. No one was permitted to enter the room when he was not there; none could do so without his specific permission when he *was* there. (It was a prime requirement of amateur painting for fun, he once said, that no one be able to see "how badly you are doing.") And in this little room the paints were always out, the brushes always ready, the canvas always on the easel. He could and did stop off in this private place for only ten minutes or so, sometimes, to apply a few strokes to a canvas; occasionally, or so he told an interviewer, he dashed in for a bare two minutes to put just a spot of color here or there on a work in progress; yet at other times—on a rainy Sunday afternoon, for instance, when he could not play golf—he painted for hours. It was, he writes, "one way to survive away from the desk" in the White House during "bad weather."

Obviously, though painting absorbed him, it did not deeply involve him emotionally. He was never committed to a picture of his in any way that made his parting with it when it was done, or his failure to achieve in it what he had wished to achieve, a painful wrench of the spirit; and no picture he ever painted was truly expressive, in any profound way, of his inner self. Said the *Saturday Evening Post* on April 9, 1960: "He paints simple, representational pictures. . . . He is impatient with art that is the product of introspection rather than observation." It would be futile, therefore, to attempt to find meaningful correlation between a picture he happened to be painting on a certain day and his dealings as president on that same day with an historical crisis or crucial domestic problem. "There's nothing philosophical about my interest in painting," he told a *New York Times* reporter in 1967. "Rather, it is the best way in the world to relax. You put the surface of your mind on the canvas while the rest of your mind is making decisions."

But surely there is a psychological significance in the mere fact that painting *could* relax him in this way. His "aesthetic impulses" were "hidden and denied," as the *Saturday Evening Post* said, but they were very real.

Indisputable evidence of this is presented in the reproductions of his work—or perhaps we had better call it his "play"—which are shown, the main substance and sole justification of this book. He himself insisted that his "daubs" were "born" of a marriage of his "love of color" to his "pleasure in experimenting." It is the latter, his sheer pleasure in experiment as a game of skill, which is most manifest in his portraits. For him, the object of the portrait game, obviously, is a precise rendering of the immediately perceived surface qualities of his subject—of skin tones, or the modeling of lips and nose, of eye shape and color, of the tones and textures of hair and clothing. Success is to be measured altogether by degrees of superficial verisimilitude. Total victory (and he came closer to it than most who

President Eisenhower and Mamie greet long-time friend Winston Churchill of England in May of 1969.

149

try) would have been a likeness so perfect that it might, at rather more than a glance, be mistaken for its living subject on any occasion where such a mistake was possible. He made no attempt at psychological portraiture. His portraits are devoid, therefore, of emotional quality.

But with his landscapes the case is different. Here it is his love of color which predominates, and his sensitivity to color in all its subtle variations is everywhere evident. Here his concern is not merely to solve an experimental problem or win victory in a game of skill; his primary concern is with beauty itself, an emotion that adheres to certain vibrations of light, even in the abstract, and becomes palpable when joined by association with remembered forms of seashore and sky, of mountains and autumn woods, of a barn of vivid red standing against a green meadow or heaped about with snow. One senses in these pictures a certain reluctance to admit that beauty truly is his essential concern, just as he refused that admission in his talk about his "daubs." It is as if he were afraid or ashamed to give free rein to his aesthetic impulse, with all that it implied of sensuous pleasure. Yet his pictures often belie his deprecation of them. They have mood. A few (his *Rolling Wooded Hills,* for example) have a Corot-like color and lyricism. They cannot but make us wonder what Dwight Eisenhower might have become had he been raised in an environment, physical and cultural, which sharpened his native sense of beauty, encouraged the growth of an interior life, and nourished (instead of starving) the aesthetic side of his character.

As a man who strove for unity throughout his entire career, Dwight Eisenhower kept close contact with all of the nation's major leaders. He often conferred with presidents Kennedy (top left), Johnson (bottom left) and Truman (left).

THE PAINTER DWIGHT D. EISENHOWER:

A Critical Look

by Frieda Kay Fall

Eisenhower was not a visionary who fancied himself a great painter, nor did he wish to be. He never laid claim to the title of artist. Modestly, he consistently insisted that his painting was only a pastime. Certainly he did not set out to be a social commentator on political, national, international or economic affairs through art. Relaxation and pleasure were his sole *raison d'être* for painting.

Just as he did not have a well-laid design upon the future in his early years when he was a young military student, he did not pursue acclaim as a painter. During a good part of his military career he was goal-oriented; not so with his artistic pursuits. As much as he enjoyed his hobby, he would not allow himself to bask in any favorable commentaries from friends, relatives or associates. End results achieved were relatively unimportant to him.

Any comparison of Eisenhower's paintings with those of others becomes pointless. He never intended that such a comparative study be made. He painted for pleasure, for the placid joy of creating images upon a blank ground; it was a vehicle for relaxation. During his life Eisenhower had looked with a clear eye at man in conflict. Then, in his late fifties he began to use the medium of paints to express what was in his mind's eye, that which pleased him or inspired him. It brought a certain validity to his basic tranquility. Violence and ferocity were not a part of his paintings for he was not attempting to communicate showing violence or a ferocious world. That was past experience. He had dwelt upon the rising and falling tide of civilizations in mortal conflict. By painting he was not striving for the moral improvement of his fellow man nor the world in general, and in his work was a conspicuous absence of any influence of the recent historical past in which he played such an important role.

Recognizable and poignant his paintings well may be, but first they satisfied his own needs for relaxation and self-expression. Small wonder, then, that the results of his pursuit do not reveal that he had been a part of man's grand drama. There was no attempt to portray the tragic or melodramatic. His canvases do not reflect any preoccupation with the state of his country or the state of the world.

In one way or another, consciously or unconsciously, man continuously constructs his own spiritual house, evolves his own channels for release and relaxation. Often the structure develops to be no more than a vehicle. Such was the case of Eisenhower and his turning to painting.

Whether ability is developed as the result of conscious willpower or reached by automatic or intuitive activities, paintings do have meaning and should possess the capabilities of being interpreted. All forms of artistic expression are highly personal statements closely connected with the unique personality of the creator. If a painting has meaning often it is only because such meaning is contained within it, not because it was intended to stand in the place of something else. On the other hand, if a painting reveals its meaning perfectly clearly and quickly this does not indicate that it is necessarily successful or important.

Everything about a painting has some kind of significance and some kind of explanation as a revelation of the personal psychological character of the painter, character which comes primarily from within the individual being of the creative personality. That has often made us neglectful or wary of looking at paintings first of all as art.

Eisenhower had no strong convictions about art. His attitude permitted him greater freedom in the use of his medium. After all, the development of individuality is the most significant

factor of the creative process, a sign of maturity. And the pictorial world of Dwight David Eisenhower began when he was a mature man. He began to paint in a time when ancient values were falling apart as new ones were seeking to establish themselves. It has long been acknowledged that conflict of man affects the creative spirit of the artist. The effects vary. Perhaps his earlier experiences, all so remote from the world of art and creativity, led to opening his eyes to new realizations of the nature of human existence and the world about him that he had not previously been able to apprehend, until his urge to paint came to the fore at a period in his life when he could allow himself time to paint.

A characteristic of painting during the twentieth century is a mingling of traditional materials, novel techniques and a loss of distinction between art forms. An enormous variety of methods was flourishing when Eisenhower was pursuing his private visions as a form of relaxation. He never identified with any movement in art, yet eclectically he sometimes subconsciously borrowed from celebrated moderns without the accumulated baggage of a sign language or symbolism, which must be learned like the letters of the alphabet. It is refreshing that he had the courage to branch out on his own individual search for a new language of expression. Outside influences did not blunt the thrust of his sincerity. In his book *At Ease* he wrote that he tried many landscapes and still lifes "with magnificent audacity."

His was an unsophisticated kind of direct communication. He made no attempt to portray meanings with visual associations and however modestly endowed, he did have a desire to express himself. Eisenhower was not seeking resolution of an artistic gift, nor was he a practitioner of any tried or tired or currently popular formula. Thus his paintings are charm-

Eisenhower always found time to devote to his paintings. This picture, showing him with the completed Castle of Chillon (Plate 27), was taken after his nomination, while he was vacationing in the Colorado mountains in July 1952.

ingly lacking in any kind of academic formalism.

He did not apply himself seriously to mastering the techniques of painting; he did not grapple with the purely formal problems of pictorial composition. He simply painted with no particular separation between reality and the imagined. His paintings are literal portrayals of familiar landscape scenes, people he liked or admired, or still-life subjects that pleased him. He made no attempt to glorify the grander aspects of nature on canvas; he simply went about the business of painting by trial and error, creating unexpected beauty in purely functional types of representations, unembellished vistas of peace and tranquility.

In satisfying his creative inclinations, his approach to his individualistic interpretations was instinctive and unstudied. Without violent manipulations or beauty-charged brushes, he aimed only obliquely at his subject matter, creating delicate musings in wistful moments of repose. His fresh, spontaneous, unstudied approach gives all of his paintings a particular appeal. His pictures reveal a strong affinity with his American heritage and a kind of philosophical serenity envelops them.

Eisenhower's paintings are not unique American documents but he did create highly original genre canvases, many of them reminiscent of peaceful, rural areas. He portrayed these in an impersonal fashion without any trace of romantic attachment. The fact that he painted portraits (and dared to attempt them), and introduced figures into many of his landscapes, reaffirms his fascination with the pageantry of life and brings into focus the personality of the man. He had no need to falsify, to make romantic or sentimentalize, yet there was an extension in his art of his own personality resulting from a love of people and places visited. Still, his paintings automatically become romantic when one is aware of the man in the role of creator.

Even while he was president, Eisenhower pursued his hobbies of golf and painting. Here he presents his painting of America's "Grand Slam" golfer, Bobby Jones, to Jones at the Augusta, Georgia, National Golf Club in February 1953.

Sometimes the ability of a painter is overlooked in the pre-eminence of the man.

With or without awareness, Eisenhower did attack his subject with feeling and straightforward honesty. He chose typical scenes that already existed in the popular imagination, which merely had to be recorded to be recognized. He took liberties with nature, yet his paintings are charged with emotional force and surcharged with moods. He would have been the first to deny it, but an emotional response to his subjects is readily evoked. With no allegiance to theory, his personal improvisations sought the feeling inherent in the subject. Witness his favoring the same subject matter over and over. Intentional or not, his work is characterized by vigor, tempered with imagination and romance. Some of his paintings approach being poetic statements with their reverent quietness, nostalgia and romantic allusiveness.

Eisenhower himself made no attempt at an extensive analysis of his efforts nor did he invite or expect any. What he accomplished emerged from his creative unconscious while he developed visual sensations for the fun of it. But he may have expressed more than he aimed at consciously in his paintings. With disciplined observation the canvases he produced were highly personalized. Modesty and humility are strong traits in Eisenhower's work, and his paintings have a warmth and intimacy that arouses admiration. Why, then, did he keep his distance from his creations and hold them and his ability in such small regard? Once they were completed, he had no deep concern for them nor any feeling of accomplishment.

Without technical proficiency, he fused his work with both vigor and a spontaneous freedom. Although he was not overly conscious of design or composition he made a careful selection of his organization of forms. There was no great attention to finish and detail but each one is thoroughly suffused with warmth. Often his loose, nervous brushwork results in a unique and personal traditionalism in his method of reporting. He made idealized portrayals of scenes that were dear to him, astonishingly convincing interpretations from a fresh point of view. Simplification of form was used as a stylistic approach.

All of Eisenhower's paintings have heroic but individualistic qualities. His self-imposed, ordered discipline is often free and informal, and frequently, there are bold, rhythmic qualities. Throughout, there is a strong sense of interrelationships of aspects of the surrounding world and relationships between form and movement and space, which become more important than descriptive detail. The supple and expressive style he developed becomes healthy and invigorating, embroidered with traces of romanticism. For him nature seemed not to be a setting or a background for his paintings but a partner and a source. It is this that lends particular appeal and richness to his canvases. He painted without photographic sleekness—his ability to simplify was used to advantage in his compositions.

Eisenhower was more concerned with color considerations than with a literal rendering of the subject. The beauty of trees, rivers and lakes fascinated him and he was preoccupied with the varieties of greens in vegetation. He once said, "I got interested in painting because I like color." Perhaps, like Winston Churchill, he thought the colors of his paints were "lovely to look at and delicious to squeeze out."

No doubt his own inner desire for expressiveness and his inherent spiritual aliveness stimulated his response to color. In many of his paintings there are muted tonalities but on the whole they are characterized by nuances of hue, tone, rhythm and harmony. There are certain folk-art and childlike qualities in much of his work, yet they retain a peculiar resilience and

buoyancy. His handling of the medium of oils and his choice of colors often bestow an eerie luminosity to his paintings. Their predominant qualities are principally achieved through rich coloring and the achievement of tonal and textural qualities through the use of the medium and brushwork.

Some of Eisenhower's sympathetic portrayals resulted in a jovial assertiveness. While the organization of his compositions generally appears to be unpremeditated, great care was exercised in harmonizing tones and hues. Colors are carefully keyed. Appealing canvases usually provide aesthetic pleasures primarily through articulation of colors and simplification of subject matter. In his *Long Covered Bridge* (Plate 47) the splashes of red of the tree on the left and his placement of it on the canvas serve as a unifying force, tying the rather simplified composition together.

In his painting *Monastery* (Plate 48), there is definite evidence of his having gained some knowledge of perspective from his course in mechanical drawing at the Military Academy. In fact, it was more than daring of him to attempt the perspective of the vaulted arches.

In other compositions simple perspective is present but not always quite adequate. He seems to have had a fondness for including winding roads, lanes and streams in his works, possibly not so much to engage the use of perspective (in a small measure) as to tie together the whole composition. At times he appears to have intentionally avoided perspective (or concealed it), as in *Old Mill* (Plate 29), where the vanishing line of the end of the mill is concealed by greenery. On the whole, there was a consistent economy of drawing.

The paintings of Eisenhower are not profound paintings but they are not without pensive appeal and charm. He did not paint them for posterity nor was he concerned with attaining economic security or public acclaim. Balance of forms simply and directly was accomplished without technical showmanship. Facile spontaneity was achieved in the application of paint from a limited basic palette. His experimentation in handling the medium is at once apparent; yet his sensitive response to color, and his fascination with it, resulted in subtle harmonies and other inherent qualities within the medium.

A more precise analysis is apt to produce the disturbing power to endow the paintings with too many unintended qualities of spirit. He would not have welcomed profound speculations about their meanings and significance, but they do not suffer from the speculations that are made about them. They speak for themselves.

Dwight David Eisenhower could not possibly have spent a lifetime of abandon in painting intimate and charming genre scenes. He developed a style to correspond with his interests and needs. It served his purposes admirably.

EPILOGUE

His love of painting and the works this talent created significantly reveal the diversity, depth and scope of his great personality. While his outstanding careers as a general and as president, and his dedicated devotion to his country and to his fellow man are now permanently registered in the annals of history and a proud part of our national heritage, the warm and human aspects are reflected in his paintings—his love of nature, his quiet but firmly rooted religious beliefs, and his response to the beauty and mystery of life. He has left a rich legacy of inspiration and example for all mankind through his active life of service, his written and spoken words of wisdom, and through his works of art.

MRS. RICHARD M. NIXON

SELECTED BIBLIOGRAPHY&PHOTO CREDITS

Ambrose, Stephen E. *Supreme Commander; the War Years of General Dwight D. Eisenhower*. Vaughan, Sam, ed. Garden City, N.Y.: Doubleday & Company, 1970.

Butcher, Harry C. *My Three Years with Eisenhower*. New York: Simon & Schuster, 1946.

Childs, Marquis, W. *Eisenhower: The Captive Hero; A Critical Study of the General and the President*. New York: Harcourt Brace Jovanovich, 1958.

Churchill, Winston S. *Amid These Storms*. New York: Charles Scribner's Sons, 1932.

———. *Painting As a Pastime*. New York: Cornerstone Library, 1950.

Clark, Edward. "Ike's Mexican Holiday," *The Saturday Evening Post*. April 21, 1962.

Davis, Kenneth S. *Eisenhower: American Hero*. New York: American Heritage Publishing Co., Inc., 1969.

———. *General Eisenhower: Soldier of Democracy*. Garden City, N.Y.: Doubleday & Company. 1946.

Dewey, John. *Art As Experience*. New York: G. P. Putnam's Sons, 1959.

Donovan, Robert J. *Eisenhower: The Inside Story*. New York: Harper & Row, 1956.

Eisenhower, Dwight D. *At Ease: Stories I Tell to Friends*. Garden City, N.Y.: Doubleday & Company, 1967.

———. *The White House Years*. 2 vols. Garden City, N.Y.: Doubleday & Company, 1963, 1965.

Gunther, John. *Eisenhower: The Man and Symbol*. New York: Harper & Row, 1952.

McCann, Kevin. *Man from Abilene*. Garden City, N.Y.: Doubleday & Company, 1952.

Nixon, Richard M. *Six Crises*. Garden City, N.Y.: Doubleday & Company, 1962.

Santayana, George. *The Sense of Beauty*. New York: Dover Publications, 1896.

2 Eisenhower painting. United Press International, New York, N.Y. **7** Eisenhower painting. Dwight D. Eisenhower Library, Abilene, Kans. **8** Letter from Eisenhower to president of Eisenhower College. Eisenhower College, Seneca Falls, N.Y. **12** Parents of Dwight D. Eisenhower. United Press International, New York, N.Y. **13** Genealogy page from Eisenhower family Bible. Eisenhower Library, Abilene, Kans. **14** First house in Abilene. United Press International, New York, N.Y. **16** The Eisenhower family store in Hope, Kans. Eisenhower Library, Abilene, Kans. **53** Eisenhower's 5th-grade class. Eisenhower Library, Abilene, Kans. **54** Eisenhower's 7th-grade class. Eisenhower Library, Abilene, Kans. **56** High school football team. Eisenhower Library, Abilene, Kans. **57** High school baseball team. Eisenhower Library, Abilene, Kans. **58** Portrait from high school yearbook. Eisenhower Library, Abilene, Kans. **59** On the way to West Point. Eisenhower Library, Abilene, Kans. **60** Mamie Doud. Eisenhower Library, Abilene, Kans. **62** West Point cadet's uniform. Eisenhower Library, Abilene, Kans. **63** Army football team. Eisenhower Library, Abilene, Kans. **98** West Point graduating class, 1915. United States Military Academy at West Point. West Point, N.Y. **99** Eisenhower in full-dress graduation uniform. Eisenhower Library, Abilene, Kans. **103** Family portrait. Eisenhower Library, Abilene, Kans. **106** Supreme Allied Commander, W.W. II. United Press International, New York, N.Y. **107** Eisenhower and "Overlord" commanders, W.W. II Eisenhower Library, Abilene, Kans. **108** top, With son John in Korea; bottom, Assuming command of SHAPE. Both, Eisenhower Library, Abilene, Kans. **109** War medals and decorations. Eisenhower Library, Abilene, Kans. **110** With paintings at mountain retreat. United Press International, New York, N.Y. **145** Donning civilian clothes as president of Columbia University. United Press International, New York, N.Y. **146** Confident of victory on Election Eve. United Press International,

New York, N.Y. **148** top left, Eisenhower and Khrushchev of the Soviet Union; top right, Nehru and Mrs. Gandhi of India with President Eisenhower; middle right, the president and Queen Elizabeth; bottom right, the De Gaulles of France and the Eisenhowers; bottom left, Eisenhower with Prime Minister Macmillan. All: Eisenhower Library, Abilene, Kans. **149** Eisenhower and Mamie with Winston Churchill. Eisenhower Library, Abilene, Kans. **150** top left, Eisenhower and President John F. Kennedy; bottom left, Conferring with President Lyndon B. Johnson; right, Eisenhower and President Harry S. Truman. All: United Press International, New York, N.Y. **153** Eisenhower holding *Castle of Chillon*. Wide World Photos, New York, N.Y. **154** Presenting Bobby Jones with portrait. Wide World Photos, New York, N.Y. **160** Formal portrait of President Eisenhower. Eisenhower Library, Abilene, Kans.

INDEX

ABOUT EISENHOWER COLLEGE

Eisenhower College in Seneca Falls, New York, is an independent, coeducational, four-year college that offers a liberal arts education.

Eisenhower College is dedicated to the character, principles and patriotism of Dwight David Eisenhower, for whom the college is named.

Chartered by the state of New York in 1965, the college enrolled its charter class of freshmen in September 1968. This charter class graduated in May 1972, with Mrs. Dwight D. Eisenhower, her son John S. D. Eisenhower and her grandson Ensign David Eisenhower attending the historic commencement.

In 1968 the 90th Congress of the United States and President Lyndon B. Johnson recognized Eisenhower College as "the permanent living memorial to the life and deeds" of Dwight D. Eisenhower.

The college's distinctive "World Studies" curriculum challenges its students to put current issues and events in their proper perspective, based on an understanding of mankind's history and cultural achievements throughout recorded history. While World Studies allows the student to gain a broad "overview" of his world, past and present, the college's January Independent Study Terms brings to the student the opportunity to focus on one particular area or subject of his choice, on or off campus, for a thirty-day intensive, in-depth study each year.

The small college atmosphere at Eisenhower brings the student into close association with the college's distinguished faculty. The college since its inception has sought faculty members who are true scholars with a love of teaching.